D1153946

TALKING TO THE WORLD

ALSO BY DENNIS LYNDS
Combat Soldier
Uptown Downtown
Why Girls Ride Sidesaddle (stories)

AS MICHAEL COLLINS
Act of Fear
The Brass Rainbow
Night of the Toads
Walk a Black Wind
Shadow of a Tiger
The Silent Scream
Blue Death
The Blood-Red Dream
The Nightrunners
The Slasher
Freak
Minnesota Strip
Red Rosa
Castrato
Chasing Eights
The Irishman's Horse
Cassandra in Red
Crime, Punishment and Resurrection (stories)

DENNIS LYNDS

TALKING TO THE WORLD

AND OTHER STORIES

John Daniel & Company, Publishers
SANTA BARBARA • 1995

FIC
L98785ta

ACKNOWLEDGMENTS

"Still Life With Doc Holliday," first published in *New Frontiers,* Vol. II, Pronzini & Greenberg, Eds., Tor, New York, August 1990. "Albert Magnus, Father Vitanza And The Hammer," first published in *Puerto Del Sol,* Spring 1987. "Marriage and Death, Solitude and Confusion," first published in *Western Humanities Review,* Winter 1981. "The Lion And The Mountain Man," and "Silvestre And Dolores," first published in different form in the novels *Castrato* and *The Irishman's Horse,* both by Michael Collins, Donald I. Fine, Inc., New York, 1989 and 1991. By permission.

The novella *Talking To The World* is based on a short story, "After Auschwitz," in *South Dakota Review,* Spring 1987.

The excerpt on p. 125 from *Neal and Jack and Me,* by Robert Fripp, Tony Levin, William Scott Bruford and Adrian Belew, Copyright ©1981 EG Music Ltd. (PRS)/EG Music Inc. (BMI). All rights in USA for EG Music Ltd administered by Careers-BMG Music Publishing, Inc. (BMI). All rights world wide for EG Music Inc. administered by Careers-BMG Music Publishing, Inc. (BMI). All rights reserved. By permission.

The excerpt on p. 127 from *Two Hands,* by Robert Fripp, Tony Levin, William Scott Bruford and Adrian Belew, Copyright ©1991 EG Music Ltd. (PRS)/EG Music Inc. (BMI). All rights in USA for EG Music Ltd administered by Careers-BMG Music Publishing, Inc. (BMI). All rights world wide for EG Music Inc. administered by Careers-BMG Music Publishing, Inc. (BMI). All rights reserved. By permission.

The excerpt on p. 125 from *O My God,* words and music by Sting. Copyright ©1983 Magnetic Publishing Ltd. (PRS). Represented by Regatta Music (BMI). Administered by Irving Music, Inc. (BMI) in the U.S. and Canada. By permission.

The excerpt on p. 126 from *Comfortably Numb,* lyrics by Roger Waters, Copyright ©1979 Pink Floyd Music Publishers Limited, used by permission.

The excerpt on p. 127 from *Synchronicity II,* words and music by Sting. Copyright ©1983 Magnetic Publishing Ltd. (PRS). Represented by Regatta Music (BMI). Administered by Irving Music, Inc. (BMI) in the U.S. and Canada. By permission.

Copyright ©1995 by Dennis Lynds
All rights reserved
Printed in the United States of America

Published by John Daniel & Company
A division of Daniel & Daniel, Publishers, Inc.
Post Office Box 21922, Santa Barbara, California 93121

Design and typography by Jim Cook

LIBRARY OF CONGRESS CATALOGING-IN-PUBLICATION DATA
Lynds, Dennis
Talking to the world and other stories / Dennis Lynds.
p. cm.
ISBN 1-880284-10-3
I. Title.
PS3562.Y44T35 1994
813'.54—dc20 94-26635
CIP

For Gayle, always

CONTENTS

SHORT
STORIES

STILL LIFE WITH DOC HOLLIDAY

ITS EYES WERE BLIND behind the cracked and dusty attic window. Faded paint eyes in a wooden face turned out toward the empty glare and tumbleweed of the desert, the unseen lizards and the wind, a hawk blowing in the silent sky.

"I guess she got a name," the first Mexican said. "The old man he give all them dolls names, you know? The old woman she use' to know all the names."

The old man had been born and raised somewhere in the East. No one in the desert knew exactly where, not even the old woman herself. Or if she did know she never told anyone in the desert. The old man's parents had been well off enough to send him to college, and after his graduation he worked for a long time in the engineering department of a commuter railroad in Chicago. The only time anyone in the desert could remember the old man saying anything about those years, beyond the fact that he had worked for the commuter railroad, was when he would tell the story of a giant sculpture he had seen in a shopping center in some Chicago suburb. A three-story steel and concrete construction of discarded refrigerators, toasters, vacuum cleaners, television sets, cameras, stereos, blenders, automatic garage door openers, and a hundred other appliances and mechanical conveniences all welded and cemented into a towering mass of broken and rusted junk.

"He used to laugh, the old man, when he told that story," the wife of the desert county's only Highway Patrol officer

11

said. "Shook his head, you know, said the people around that shopping center got real mad when they saw all the things they worked so hard to get sitting up there like junk. All the stuff they went to the shopping center to buy! The old woman said the sculpture showed everything the center sold for what it was."

The old woman came from Georgia. Before she met the old man she had been a professional dancer and actress in New York and Chicago. When she hurt her leg she had to give up her dancing. She became a school teacher, told the people in the desert she really never had been a good enough dancer or actress anyway. She taught school in the same Chicago suburb where the old man had seen the giant junk sculpture. They met and married before World War Two, and some years after the war left Chicago to come west to where the old man went to work to help develop a new rapid transit system and the old woman taught school again.

"The old woman put that one up there at the attic window the day after the old man died," the pastor of the desert Methodist church fifteen miles up the highway said. "I don't know what faith they were, they weren't part of our congregation, but they brought the dolls over to Sunday School and gave shows for us at fund raising events. Good neighbors. The old woman said the one up at the window liked the old man best, so she put it up there after he died to watch for him out in the desert."

The old man became one of four engineers summarily dismissed by the transit management for publicly warning that proper engineering practices were not being followed, and that unless significant corrective steps were taken an unsafe and unreliable public transportation system would result. Various professional engineering organizations took up their cause. After a number of years the transit system finally made a substantial out-of-court settlement, and the old couple ended up "a thousand miles from nowhere" on the abandoned ranch in the desert where the old man began to carve his life-sized dolls.

"Them engineering people give him an' the other guys a

prize for what they done, riskin' their jobs 'n all to help the public, you know?" the second Mexican said. "A certificate an' five hundred dollars. The old man he had the certificate an' the check nailed up on the flagpole outside. It had his name in gold 'n all, the certificate."

Twenty miles from the nearest town of any kind, they named the place "Furnace Rocks" in honor of the relentless sky and shimmering landscape. A barren cactus and yucca homestead set behind unpainted fence rails in the center of an infinite space in endless shades of yellow and brown and gray. There, in what had once been some former owner's tool shed, the old man carved his dolls and the old woman helped him dress them. In the end there were over seventy of the hand-carved and painted dolls, all with hand-made clothes and the best quality human hair wigs.

"Most folks called the place a junkyard with all the dolls and stuff layin' around the yard," the operator of the ghost town up the road said. "I happen to know some art gallery owner from L.A. come up here once and offered ten thousand dollars for the dolls. The old man just shooed him off, told him the dolls belonged right where they were in the desert."

The old couple built an elaborate doll theater beside the ramshackle house. The old man painted a life-sized portrait of the tubercular outlaw dentist Doc Holliday—heavy black suit, gambler's string tie, gold watch chain across his vest, pale and cold-eyed, his favorite weapon, a shotgun, held muzzle down in his right hand. He hung the painting over the stage and called the place The Doc Holliday Desert Theater.

"The old man said it was because he and the old woman came to the desert for their health just like that mean scoundrel," the pastor laughed.

Outside, some of the dolls circled on wind-turned carousels. Others rode on swings and seesaws pushed by the constant desert winds. Tourists on their way to the ghost town three miles farther along the county highway began to stop at the theater. The old woman sold them soft drinks from a stand at the theater door.

"Only place you could get a cold Dr. Pepper for twenty miles," the wife of the Highway Patrol officer said. "Except over at the ghost town, o' course, but he charges a sight too much."

Inside the theater the old couple's oak and redwood family came alive for the passing audiences. There on the small stage in front of the darkened benches the life-sized dolls would talk and act, sing and dance. Behind the old-fashioned footlights they would perform original plays written by the old woman about her life before she came to the desert and the peace of her life in the desert, recite the old man's humorous and sometimes bitter observations on the state of the world beyond the desert. They would pedal stationary bicycles mounted on the stage, climb ladders, and even fly high on swinging trapezes.

"The old woman she was real proud o' the one named Helen, you know?" the second Mexican said. "She use' to tell ever'one, 'That Helen wave her arms an' kick her leg up. Men they really like it when Helen lift her leg like that.' Then she laugh like hell, you know?"

When the old man died, the old woman stayed on alone at Furnace Rocks in the dilapidated house. She refused to think about selling the house or the theater or any of the dolls. She grew weaker, the injured leg from her dancing days became worse, and without the strength to operate the theater alone, knowing the old man wouldn't have wanted anyone else to run it even if someone could have been found there in the desert, she had to close the theater. She stopped selling the cold drinks to the passing tourists. Trash piled up inside the house. Dust settled undisturbed on the furniture, on the faded portrait of a sagging Doc Holliday in the theater, on the life-sized dolls.

"Some of the church folks tried to clean the place up for her," the wife of the Highway Patrol officer said. "She called me all alarmed. She said they didn't know what was in the house, they'd throw Babe Tangerine in the truck with the trash, or even Miss Maple and Helen. I had to go out and stop them before she'd calm down."

The merry-go-rounds revolved unwatched in the wind.

The swings and seesaws rusted and stopped moving at all. The dolls stopped dancing. The tourists stopped coming. The old woman herself died in the decaying house beside the silent theater. The pastor of the desert church found her body.

"She was in a chair," the pastor said. "She'd been dead for some days, I'm afraid. The dolls were all around her on other chairs, on the couches and in the beds. All over the house, the dolls. Covered with dust. Trash and dirt everywhere."

The two Mexicans and the wife of the Highway Patrol officer had her buried in the desert cemetery with the old man. Relatives came from Georgia to inspect the "estate" she had left them, and decided to sell the whole place as quickly as they could. When no buyer appeared, they told the pastor and the wife of the Highway Patrol officer to sell anything and everything for any reasonable price, and went home to Georgia.

"They din' even put no stone on the old woman's grave," the first Mexican said.

The dolls remained where the old woman had last put them. Some as if asleep in their handmade beds with the hand-sewn covers. Some on the swings and carousels that no longer moved in the desert wind. Some still poised to dance in the hot and empty rooms. A few sat at windows in their special chairs. Others sat at tables in the living room and the dusty kitchen.

The portrait of Doc Holliday, shotgun scoured away and black suit peeling, hung above the silent stage. The one tall doll with the faded paint eyes stood at the high attic window looking out across the desert.

ALBERT MAGNUS,
FATHER VITANZA,
AND THE HAMMER

ALBERT MAGNUS

JUST BEFORE or after the last big war, an old man, Albert Magnus, lived with his wife, his mother, and his seven children in a mud and palm thatch hut in a village on a large estate in a valley ringed by mountains. He did not know if it was before or after the war. He did not know there was a war, or what was outside the valley except the capital city of the country where the *baas* went to meet with the other landowners who ruled the country according to the laws God had given them.

Almost fifty, his dark face was all deep wrinkles burned black by the sun of the fields. His body was thin from the coca leaves he chewed. He walked slowly from lack of protein and the parasites that entered through his bare feet. His back was bent and his legs twisted by the short hoe he used to chop weeds from the fields of cotton.

On this day Albert Magnus had been cutting bananas since dawn, piling them into a two-wheeled ox-cart, and taking them to the long sheds where they would be loaded onto the narrow-gauge railroad and taken down to the ocean he had heard about but never seen. He was not at all sure it really existed, since the man who had come into the valley to tell about the ocean was a liar the overseers had thrown onto a banana train out of the valley.

The sun was low over the great hacienda with its red roofs

16

and corrals and gardens when he started back for the village, and the last rays flashed off the object in the dirt track. Albert picked up the object. It shone like the silver conches on the saddles of the *baas* and his sons. The color of the tall candlesticks in the church on the hill across the valley. As beautiful as the silver snuff box of the old *oombaas* himself.

As Albert turned the strange object in his twisted hands it shot a stream of fire. He stared at it, astonished. Then the flame burned his hand and he dropped it. He was a brave man and picked it up again. He studied it and saw that by pushing one place a wick appeared and burned as brightly as any candle. In his excitement and wonder he forgot the law of the valley that all things found must be taken immediately to the hacienda.

He took the silver object to the village and showed it to everyone. The women were all afraid. The men were amazed, but careful to hide their amazement, and scornful of the fears of the women. The men laughed, if nervously, every time Albert made the fire from nowhere. He did this for some days until the flame would not appear anymore. Then someone in the village told the priest who told the *baas* who sent the overseers to bring the object and Albert Magnus to the hacienda.

Albert told the overseers how he had found the strange object in the road at sunset and was so amazed by the miracle of its fire that he took it to the village without thinking that it could possibly belong to anyone but God so was unaware he had broken the law of the valley. The head overseer locked Albert in the guardhouse that had been built centuries ago for defense against the marauding ancestors of Albert Magnus, and went to present the old man's story to the *baas*. The head overseer believed Albert's story and recommended a mild whipping and three days loss of pay and coca leaf.

But the *baas* explained to the visiting American who had lost the cigarette lighter that it was a most important law the old man had forgotten. Without it the peons would soon be "finding" all manner of valuables and not returning them, and eventually they would all start to steal anything they wanted. The difference between finding a lost object, and finding what

was not really lost but only something they saw and coveted, was not a distinction their primitive, uneducated minds could make. And, anyway, a law was a law and had to be enforced rigorously or no one would fear the law.

The *baas* reported Albert to the Governor of the province, and soldiers came to transport him to the penal colony at the mines in the north of the country. Before he was taken away, Albert made his confession to the priest in the church on the hill across the valley. He told the priest what he had told the head overseer. It was all he had to tell. The priest told him he had sinned and must accept his punishment humbly. God had approved his punishment in this world, but he would be for-given in the next world where everyone lived in happiness and comfort without having to work in the fields or the mines, provided they had fulfilled all duties and atoned for all sins in this world.

His mother and wife and seven children stood in the road and watched the soldiers take him away. The soldiers rode horses while he walked behind with a rope around his neck. He walked with his head down in guilt, did not look at his wife and mother and children. What would they do without him to work? Because of him they would suffer terribly, perhaps starve. None of the other villagers left their huts. That would not have been right. Albert Magnus had committed a crime against the *baas*, the country, and God. The *baas* ordered the priest to ring the church bells and announce there would be an extra supply of coca leaf and beer in honor of the Governor.

The *baas* and his sons and the American visitor sat on the patio of the hacienda and listened to the celebration of the peas-ants while the servants brought their rum and cigars. There was music and dancing all night, and everyone got drunk and had a fine fiesta. Except the mother and wife and seven children who were ostracized by the rest of the village because Albert was a criminal. Shunned, the mother soon died, the seven children grew up and moved to other villages where their father's crime was not known, and the wife lived on alone in their hut, begged food, and washed for the wives of the overseers.

Some years later Albert escaped and came back to the valley under the cover of night. No one would open a door to him, not even his wife who had almost forgotten him and had a new man who might want to marry her if the *baas* approved. The *baas* flew into a violent rage and turned the dogs loose. They easily ran Albert down and tore him to bits. The priest refused to bury him in consecrated ground since he was an unrepentant criminal. His wife married the new man, and the church bells rang across the valley for the fiesta in honor of the good *baas* and his sons who watched on horseback with their silver saddles shining in the sun like the cigarette lighter of the American.

§

FATHER VITANZA

The young priest, Father Vitanza, had been sent from his remote country for study and meditation at the Monsignor's retreat house in the northern city. His bishop and the Monsignor were friends from the Monsignor's days as missionary to the Indians of the young priest's country.

"You have to picture the church, Monsignor. I mean, the ranch is so big it would cover this whole state, and there are a hundred villages, and the church is all by itself on a dusty plain near the main house. Most of the villagers live too far from the church to come to it, so I go around the villages and hold Mass in the chapels they build for themselves. But all the villagers try to come to the big church a few times a year, and on Christmas and Easter it's always packed to the walls."

The wind blew old snow outside the high, narrow windows of the large living room in the Monsignor's residence, but the Monsignor could almost feel the heat, smell the dust, of the distant country where he had performed his missionary labors. He smiled his famous crooked smile that was the joy of parishioners and the terror of politicians who opposed the Monsignor's causes.

"I've been among your people, Father Vitanza. Their devotion under hardship is amazing. Perhaps the lack of a formal church most of the time actually strengthens their faith. It's something I've often thought about, something we should all think about up here where our faith is so easily served, eh, Father Daly?" He turned his smile on the older priest who sat with them.

"Establish a building fund for a new church, Father Vitanza," Father Daly said. "That ranch sounds rich, and the poor always give if you call from the pulpit, tell them it's an offering."

The Monsignor, who was considerably younger than Father Daly, smiled again. "The situation isn't quite what it is here. Those people don't have money to give."

"Barter," Father Vitanza said, "and credit from the ranch's stores. The *padrone* wouldn't like a building fund anyway. His great-grandfather built the church, his family makes all the offerings. The church belongs to him."

"We don't like that, do we, Monsignor?" Father Daly said.

The Monsignor didn't answer. He watched the young priest. It was warm in the comfortable, overstuffed room with its dark wood and burgundy velvet upholstery. Father Vitanza seemed to see the distant *padrone* and his church.

"It's one long room like a cathedral. There's even a kind of steeple—a tall bell cradle on the roof. The bell came from Europe a long time ago. It's built of local brick, the church, stained glass windows brought from Europe too. Polished stone floors, a high wooden roof it must have taken all the peasants on the ranch back then to build. It's hotter than hell in summer. Sorry, Monsignor."

"I know the word, Father," the Monsignor said.

The Monsignor felt the heat in the office and in the distant country of dust and scorching sun. He was uneasy as he listened to the young priest, wondered where this rambling discourse of churches and peasants and *padrones* was leading. He didn't think it was a new church Father Vitanza wanted.

"The altar's at the front, all gilt on oak, with a railed sanctuary. The altar and sanctuary were brought from Europe on

sailing ships a century ago. In front are the pews. They're local wood stained with animal blood and polished until they shine like ebony. There are twenty rows of them, they take up about a quarter of the church. They end in another rail and gate, and behind that rail is the three-quarters of the church where the villagers stand."

"Who uses the pews?" Father Daly said. "There's where you get your next church."

"The ranch people use the pews," the Monsignor said. "The landowner's family, and the overseers, and other retainers."

"You understand, Monsignor," Father Vitanza said, nodding. "Yes, the pews belong to the ranch people. The back fifteen rows are used by the foremen, the skilled workers and their families, the mounted attendants of the *padrone*. All those who live at the main house. The next two rows are for the lesser relatives and visitors. The front three rows have gates, are for the *padrone* and his immediate family and official guests."

"Quite customary in Europe," Father Daly said. "Even in old churches in this country for local first families."

"Change comes slowly," the Monsignor said to Father Vitanza, smiled his famous smile.

"You can see the church, then?" The young priest looked into their faces. "All right, the *padrone* is a good Catholic, comes to church every Sunday without fail. He makes his entrance only minutes before the mid-morning Mass is to start. Dressed in his best suit, he walks through all the people who are standing. Like Moses parting the Red Sea. He's quite an imposing man, goes into the first row of his pews, takes the first seat on the aisle. His family has come in ahead of him. Sometimes he'll bring an important guest, escort the guest to a seat in the second row of the pews, then take his place—first row on the aisle. There he kneels in prayer for a full two minutes, telling his beads. Finally he sits back and it's the signal to start the service. We still use the Latin, the *padrone* doesn't want vernacular or participation. He's always the first at communion. He comes to the rail, kneels alone, and takes communion alone. Only then do his family, guests, the ranch hands,

and finally the villagers come forward. When the Mass is over he walks out first. Then they all follow him."

"The mighty have their privileges," Father Daly said.

"Yes, yes, exactly!" Father Vitanza wiped his forehead in the warm room. "Then one Sunday two months ago it happened."

"The rebel attack?" the Monsignor said. "As I understand it there were few casualties, the soldiers drove them away. I hope none of your people were killed or injured."

"Some guerrillas and soldiers, may they rest in peace." The young priest crossed himself, touched his hand to his lips, bowed his head. Then he clasped his hands on his knees. "They came on Easter Sunday morning. I don't know when they actually reached the ranch, but they arrived at the church as I was offering communion. The *padrone* had just come to the rail to kneel alone. We heard the trucks, smelled the dust, listened to the feet all around the church. The back door flung open, the villagers at the rear began to open up exactly as they did for the *padrone*, and a young man walked through them to the gate into the pews."

Father Vitanza's entwined fingers opened and closed on his knees in a kind of excitement. "He couldn't have been any older than I am. He was small, thin, dressed in camouflage fatigues obviously captured from the government forces, had what I'm told was a Russian AK-47 slung over his shoulder and a red armband on his left sleeve. He stopped at the gate into the pews. His eyes looked over everyone, looked at me, and then at the *padrone* at the rail who had not even turned around. When the young man opened the rear gate, the *padrone's* sons and some of the overseers started to move. The young man touched his rifle, nodded to the rear and to the side windows. We could see the other guerrillas all around. There was nothing the sons could do.

"The young leader walked straight down the aisle between the rows of seats, opened the gate at the front, and knelt at the communion rail beside the *padrone*. Not to his left, but to his right. In effect taking the *padrone's* exact place—the first one at

the rail on the right. The *padrone* stared at the young guerrilla beside him. They looked at each other. The *padrone* at least six inches taller even kneeling, yet it was almost as if they were the same height. Perhaps because the Russian rifle jutted up that far above the boy's head there at the communion rail."

Father Vitanza seemed to see that Russian rifle jutting up in his church. So did the Monsignor, a frown on his slender, ascetic face instead of the crooked smile. Father Daly's face was outraged. The intense young priest did not notice the old priest's anger or the Monsignor's frown.

"Then the boy looked up at me and nodded. He wanted me to go on with the communion, wanted to take communion. I asked him when he had last confessed, but he only stared at me. I had no idea what they might do, the church full of women and old men, so I gave them both communion side by side, the *padrone* and the young guerrilla. When it was over, the young man stood and walked up the aisle and out through the people exactly as the *padrone* himself did every Sunday. The villagers parted for him just as they always had for the *padrone*. They followed him out without waiting for the *padrone*. The main house people went out too. Only the family was left in the pews, the *padrone* himself alone at the communion rail still looking straight ahead at the altar."

Father Vitanza looked toward the high, narrow windows and the blowing snow outside the warm room. "He was like the first Christians, you see? That young Marxist. I know those people, and he was different. I remember learning once that the great strength of Christianity in the early days was that all a man had to do was become a Christian and he was the equal of the Emperor. Slaves, plebeians, farmers could join the church and instantly were as good as the Emperor in the eyes of God and in their own eyes. And that's what he was like, that young guerrilla—the equal of the *padrone*, of anyone."

Father Daly said. "He had guns. They all had guns."

"There are bandits with guns," Father Vitanza said. "We are a poor country, there are many bandits with many guns, and they're not like him. No, it wasn't the gun, Father, it was

the armband. It made him the equal of the *padrone* instantly. Like an early Christian."

The silence in the room of dark wood and burgundy velvet was as heavy as the furniture itself. Father Vitanza sat as if he saw a vision of the scene in his distant country. The Monsignor wished Father Daly wasn't there. The old priest was red-faced, choleric. He had been born in the slums not far from the retreat house, one of twelve children of a bricklayer and his pious wife who had prayed for a son who would be a priest. Loyal to the church, a staunch friend of the rich among whom he had moved most of his life, baptizing, marrying, raising funds.

"Barbarians. Scum," the older priest said. "Desecrating the church! Where were the soldiers?"

"The guerrillas did nothing to the church. Took supplies from the ranch, some men from the villages. The government troops caught up with them beyond the ranch. There was a small fight. The guerrillas escaped into the bush." The young priest looked at the Monsignor. "It was God telling us what we must do. A sign. God showed us what He wants from us."

"That's blasphemy," the older priest said, "if it isn't heresy."

"That's enough, Father Daly," the Monsignor said, and said to Father Vitanza, "It's a long time since God spoke directly to us, Father, and signs tend to mean whatever the interpreter wants them to mean. Oracles and prophets, alas, haven't been heard in many centuries. One must be careful, even suspicious, of divine communication. It's so easy to let our sentiments mislead us."

The young priest looked at the floor, seemed to listen to the wind outside the high windows. "I don't know, Monsignor. All I know is I saw this and I knew it was a sign from God telling us what we must do for our people."

"And for the Church?" Father Daly said.

The Monsignor stood up. "I'm sure Father Vitanza means for both. Now it's time for evening meditation, we'll talk more tomorrow, Father. Think about your feelings, meditate, pray for guidance, that is what we are all here for."

The young priest sat with his eyes cast down as if once more going over his feelings, his vision of what he had seen. Then he abruptly stood up, nodded to the Monsignor, and left the room. The Monsignor and Father Daly looked after the young man as the door closed.

"Heresy, Phil," the older priest said. "That's what it is."

"I don't think so, Frank. He's simply seen a lot too much suffering around him down there. That, and some misplaced zeal. Anyway, we don't burn them for heresy now."

"More's the pity!"

The Monsignor sat in the warm room for some minutes without responding to the old priest. Dirty snow blew outside the high windows of the retreat house in the northern city so far from the dust of Father Vitanza's country.

"There was a Christ once and He established the way of the world for all time, Frank?"

"So he did, Phil. So he did."

"And established that the *padrone* should have the big pew and kneel alone at the communion rail?"

The Monsignor came from a wealthy, civic-minded, so-cially-motivated family devoted to public service and the good of the people. He thought now of his family and their years of service to the nation, all their good works. A long and proud record. Would it all be irrelevant?

"I didn't say that."

"Didn't you, Frank?" the Monsignor said.

§

THE HAMMER

The massive river coils from the jungle and flows broad past the wide lawn and tall trees and sprawling villa of the plantation. If passengers on the jets between the inland state and the capital of the country, or on one of the busy helicopters of the American oil exploration teams, look down, they see an end-less green unbroken in all directions except for the villa

grounds and the great river itself whose course can be followed for hundreds of miles by the curving break in the vast green floor.

Even the tributaries are invisible under the endless green that seems to floor the whole sky. Only the river and the great villa with its whitewashed walls and black timber roof and broad lawn that slopes down to the edge of the river in front, spreads between the villa and the animal pens and storehouses and sawmills and blacksmith shops and stables, and all the other buildings needed to be self-sufficient, on the other three sides. Beyond the lawn and the outbuildings are the small houses of the foremen and other villa servants, and behind these a village of natives who worked for the villa but were not of it. Then the jungle. In the jungle are many other villages, but they cannot be seen from the villa or the sky, have little to do with the villa until it is time to pick the crops or tap the trees when the chief foreman, sometimes even the *tuan* himself, goes out to round the villagers up for work.

The young man who came in the night down the great river paddled close to the shore where the overhang of the trees hid him in shadow even when the moon rose. His black face glistened in the hot night, and he wore the black shirt and trousers of the elite forces of the country's army. His only weapon was a broad, heavy knife as long as a sword. He passed all the piers that jutted out into the river from the shining lawn of the villa for the river boats to take the products of the plantation down to the ocean for shipment across the world, and hid his canoe in the dense growth where lawn and river and jungle came together.

There he waited until the moon was gone.

Toward dawn he moved silently across the great lawn past the villa and through the animal pens and barns. Past the horse stables and the rows of storehouses for the many products of the plantation and the small houses of the foremen and servants. To the mud and thatch huts of the village against the jungle wall. There he stopped at one hut, glanced around the moonless night, and slipped inside. A young woman lay sleep-

ing between two small children. The young man kneeled on the dirt beside her, sat back on his heels. The young woman sat up in the dark interior.

"What is in the night?" the woman said in her native language.

"Your husband is in the night," the young man said.

The woman looked toward the door. She rose to the same kneeling position, sat on her heels.

"Your mother will be happy."

"You are not happy?"

"The *tuan* will not be happy."

"The *tuan* is not here."

"I am afraid."

"We will talk, the *tuan* and I."

In the dark her eyes were white.

"The *tuan* talks only with *tuans*!"

"That was yesterday," the young man said. "I have a name now. I am called: The Hammer."

The young man's eyes were dark. The woman lay down on her mat. The young man lay beside her. The weight and chatter and cry of the jungle rested on the silence of the hut.

For three days the young man slept with his wife at night, and by day walked through the dark light of the jungle to the many villages. For three days he talked to the men who squatted in the dirt and listened to him and looked at what he told them was tomorrow. For three days he told them he would talk to the *tuan*. He would tell the *tuan* that it was time to talk about tomorrow. They all watched his young face that glowed like polished ebony in the shafted jungle light.

After three days the men from the villa came to the mud hut behind the outbuildings and dragged the young man away from the wife who lay with him on the mat. The young man seized his heavy knife and drove them back. They stood astonished as he put on his stolen soldier's uniform, thrust his knife into his belt, and walked ahead of them through the outbuildings and animal pens and stables and across the lawn to the villa.

The *tuan* sat on his veranda. When he saw his foremen and servants walking behind and on both sides of something, the *tuan* turned his head slowly to look at what it was that walked across his lawn toward his villa. Toward him. He sat in silence for some time as the young man waited below the veranda in his soldier's uniform. Then the *tuan* stood. He called for his sons. They came and stood behind him. He looked at the young man but spoke to the chief foreman.

"You were told to send him from the villa."

The chief foreman said, "He would not go."

"Make him go."

"He says he will talk to the *tuan*."

The *tuan* stared amazed at the chief foreman. Some of the sons laughed. Some swore.

"Then kill him."

The young man slowly raised his left hand in a clenched fist. He thrust the fist into the air and toward the *tuan*. He began to climb the steps of the veranda toward where the *tuan* and his sons stood. The *tuan* stared at the foremen and the servants. They watched the young man almost without breathing.

"Get off this veranda, you scum," the *tuan* said to the young man.

No one had ever seen the *tuan* speak to a villager.

The young man stood on the veranda with his clenched fist straight up, his eyes wide and triumphant in his black face. The *tuan* drew his pistol and shot the young man four times, blew him backwards off the veranda onto the great lawn that turned red under his dead body.

"Throw the scum into the river."

The *tuan* turned and walked into the great villa with its whitewashed walls and black wood beams.

The foremen and servants dragged the young man's body across the smooth lawn toward the river. Villagers appeared from the jungle, stood between the foremen and the river. The foremen and servants stopped dragging the body. The villagers picked up the body and carried it back across the lawn and through the stables and outbuildings to the mud hut where the

young woman waited. The wife and the two children washed the body in water from the river. An old woman knelt beside the young man's body, took a red armband from his pocket, and slipped it onto his sleeve. The villagers carried the body to the church behind the big house. They laid the body on a long bier in front of the altar as the priest would have displayed the body of the *tuan*. The priest did not come, but one of the old men said the ceremony and some younger men rang the bells.

In the villa the *tuan* sat in his living room and listened to the bells. He got up and locked the doors. When the church bells stopped, his sons took their rifles and went out. The *tuan* drank a whisky and soda. When his sons returned they told him the wife and the children and the mother and the whole village were gone. The village behind the villa was empty.

SYLVESTRE AND DOLORES

THE VILLAGE LIES BETWEEN the mountains and the jungle. No one in the village knows why the village is there or who built it. It has always been there. The people have always been there. The land has always been there, and the landowners. Everything has always been done in the same way.

Most of the people work on the large fincas where the landowners grow coffee, cotton, sugarcane, and even some bananas. The bananas were brought from the eastern coast where the great foreign plantations used to be, although the villagers do not know this. These crops are all for export, mostly to the United States. The wealth of the nation comes from these export crops. They are the source of everything the country builds and does, of the income of the government and the middle class, the pay and power of the military.

The villagers have no choice but to work on the fincas, to plant and tend and harvest these export crops. There is no other way to earn the money they must have to support their families and the village. There is no way to earn extra money to leave the village and find better work in other places. There is no way to raise and sell crops of their own that might give them enough money to not work on the fincas, or to leave and look for better work. No way to do more than subsist in the months when the fincas do not need them to work.

A circle of perpetual toil for perpetual poverty. The men work all day on the fincas to earn enough to survive the

months when there is no work, come home and forage for extra food, cut wood in the forest for heat and cooking and to, perhaps, sell in the market town, tend to the few animals. The women bear the endless children, raise them, watch most of them die from lack of the food children must have to grow. The women tend the small plots where the few vegetables are grown, make the clothes, wash the clothes, mend the clothes, weave and make baskets to sell in the market town for a few extra coins.

No matter how hard or long they work they do not have the food to sustain this endless work on the fincas of the landowners and in their own small village. Most can barely rise each new morning to go to work, live day in and day out in lethargy, exhaustion, and mental depression. The children who somehow live do not have enough protein to allow their brains to develop fully, will never do more than work on the fincas, cut wood in the steep forests, weave blankets to sell for nothing to American tourists.

In the village between the mountain slopes and the jungle, Sylvestre Madrona is one of the stronger children who survive. He can work harder than most, and he is angrier than most.

"He is the lucky one," Madrona tells his wife when their first child dies. "The child is better off, Gabriela. He will not live as we live. We will have a fiesta to celebrate!"

The men get drunk and chase the women through the village. The younger women laugh and scream and hide but not too well. They all dance in the night after they bury the child.

In his young days, before and after the death of his first-born son, Sylvestre does not drink much. He can and does work harder than most men in the village, has more food in his garden for the other children that will come each year, is noticed by the local manager on the finca where he works. It is the largest finca, over fifteen thousand acres, is only one of many owned in the nation by the great Alvarado family so pure in its European blood and ways that an Alvarado is insulted if called ladino.

"You work well, boy. What is your name?"

31

"Sylvestre Madrona, jefe."

"Do you think you can boss a field crew?"

"I do not know."

"Well, I say you will do this well and I know what I say."

"Yes, jefe."

"I will speak to the padrone."

Sylvestre becomes the straw boss of all the men from his village, is expected to encourage the men to work harder and pick more. He tells the villagers that if they all work together they will all make more money, works harder than anyone. They do earn more money, but Sylvestre earns the most, and soon Gabriela is in tears when he comes home. Exhausted he lies on their mat and listens to her tell of all the women who will not speak to her when they wash their clothes in the river. The men who insult her and come at night to bleed her goats and trample her garden. The children who steal food from their children.

The village men will no longer drink with Sylvestre. At fiestas he is alone, in the religious processions he is given no part. In the fields they will not eat with him, in the village they walk away when he comes near.

"You do not understand," Sylvestre tells them. "I have a plan for the money we all will have. We will all save our money and we will grow corn like the ladinos. We will clear a field and make a place to grow our own corn to sell in the market town. Then we will have money to grow more corn and even cotton to weave into the blankets and sell more. It will be slow, but it is the only way we will ever have our own money and not have to work on the fincas."

The villagers are skeptical, wary, reluctant. They have always failed at whatever new they tried, have always failed at any risk they took. The smallest triumph has always turned into nothing. Sylvestre persists. He cajoles, persuades, encourages. He contributes the most money, borrows the tools from under the nose of the finca manager without permission, organizes, works the hardest to begin the clearing of the field. It is hard to do the backbreaking work after a long day on the fincas, but the field is at last planted.

The corn sprouts and grows tall and each night the whole village goes to stand and look at it. Then the rains do not come. On the fincas the landowners irrigate. In the village the men watch the corn die. On the finca where Sylvestre works the manager discovers that he borrowed the tools without permission and makes another man foreman. In the village the men get drunk. Sylvestre joins them. There is no use trying to change their lives. The way it has always been is the way it will always be. God Himself does not want the village to change, wants them to work forever for the landowners on the fincas.

Sylvestre drinks more, works less, sinks into the lethargy of the village. Gabriela grows fatter, his children die or do not die. He works on the finca, cuts wood to sell so he can buy aguardiente to get drunk at festivals, sleeps in a stupor many nights. He, and the village, are barely aware when a new padrone arrives at the largest finca. One landowner is the same as another. The work will always be long and hard, the pay always not enough. Why would the village care who is padrone? It is over a year before Sylvestre and the village become aware that this new padrone is not the same.

A giant golden-haired man, he speaks bad Spanish with the accent of a norteamericano. The manager, who has ruled the finca longer than all but the oldest men of the village can remember, is no longer manager. All the old padrone's staff are gone. The men of the new padrone do not know about coffee and cotton and sugar cane or even bananas, walk with guns, ask many questions when anyone goes on the land of the finca. These new men stand on the roof of the finca and watch all day. Large cars arrive at the finca with generals in magnificent uniforms and well-dressed padrones and almost naked ladies who laugh and lie on long chairs beside a pond the new padrone builds in the ground.

The new padrone also builds, in a remote part of the finca, a wide road of black that goes nowhere. Great birds fly down from the sky to the wide road and fly away once more at night. A smaller square of black is built near the house itself where the birds with windmills come. This is all strange to the village,

but strangest of all is the great money the new padrone pays for work.

"What kind of fool is this padrone?" the oldest villagers ask.

"He is from another country where they pay such monies," a younger man who has been once to the capital city says.

"He is a *norteamericano,* a *yanqui.*" This man spits in the dirt.

Sylvestre says, "What does it matter who or what he is? His money is from paradise."

The others are not sure. They are wary again, suspicious. Nothing can change, nothing can be better. Sylvestre himself is not sure, but there is something about this yanqui padrone that reaches inside Sylvestre even when he lies drunk on his mat in his shack at night. He sees in this strange man an alien world of which he understands he knows nothing. A world far even from that of the old padrones who have always owned the fincas, the generals in their resplendent uniforms who sometimes came to the old padrones and who now come to this new padrone. Somehow, Sylvestre is aware that it is the world of the great silver birds that fly high in the sky over the village, that come from where Sylvestre does not know, and go to where he does not know.

"This padrone is not as the others," Sylvestre tells the men. "This padrone is not as always."

When the new padrone comes to the village with a crop he will pay the villagers to plant in fields they will clear from the mountain forest above, Sylvestre is the only man to listen. The others are afraid, see evil magic in what they have never done, a crop that cannot be eaten or drunk or made into clothing. When Sylvestre hears how much money the yanqui padrone will pay for the villagers to plant and harvest the new crop, he too is afraid. What could be worth so much money?

"Poppies," the new padrone tells him. "A flower that makes medicine people who want beautiful dreams will pay very much money for. I will buy all you grow, make the medicine myself. All you have to do is clear the fields under the trees and plant the flowers."

"I am afraid," Sylvestre tells the new padrone.

"That's what they want you to be," the new padrone says. "The generals and the landowners want you to be afraid."

"I do not understand what it is you tell me."

"They do not want you to understand, Sylvestre. The landowners and the generals. They want you to be an ignorant man as well as a poor man. They don't want you to know why your village has always been the same and always will be."

As he listens to the golden-haired giant who has taken the largest finca from the landowner who always owned it, Sylvestre is more afraid than he has ever been. Inside he is shaking, because somehow he already knows what the padrone is telling him, and knows that it is true.

"The truth, Sylvestre, is that you and all the villages must be ignorant and poor to make your country work. You have to be ignorant and poor or the generals and padrones could not keep what they have. You have to work all your life to grow the crops for export."

Sylvestre does not understand all the words the big yanqui padrone uses, but he understands what he is saying. The padrones could not live in the fincas if they did not have him and the other men of the village to plant and pick the coffee and cotton and sugar cane and bananas for not enough money to live. For not enough money to feed their children. For not enough money to ever leave the village.

"All you are is a cheap back, a pair of hands, and a breeder of more cheap backs and hands. Your country is built on keeping you poor and weak, and my country helps the rulers of your country keep you poor and ignorant because we want cheap coffee and cotton and sugar cane and bananas. Your children die, Sylvestre, to always keep bananas very cheap because Americans don't want to pay too much for a banana with their breakfast."

Sylvestre understands enough. All the years he lay on his mat and listened to the night of the village he has known deep inside that something was not right.

"I will plant the flowers, padrone."

"I'm not a goddamn padrone, Sylvestre."

The other villagers are too afraid to plant the new padrone's flowers, do not dare to do what they have never done. Sylvestre must take Gabriela and the older children and they clear a small field, plant the poppies. Sylvestre takes care of them, nurses them, harvests the raw opium. He earns more money than he has ever had, talks much with the yanqui padrone.

When Sylvestre is growing his third field of the miracle flowers, the soldiers come. The villagers all hide, but the soldiers find many who tell them that it is Sylvestre who grows the strange flowers. The commandante of the soldiers arrests Sylvestre, is going to burn the field and his shack and take him away when the new padrone arrives from the finca with his men. The yanqui padrone talks to the commandante. He gives the commandante a fine cigar. They go together to the finca. Soon the soldiers go away. They do not take Sylvestre, they do not burn the field.

The yanqui padrone laughs. "Everyone needs more money, even that commandante's general, and one field is no threat, right? Cut the general in for enough, slip the commandante a taste, and they couldn't care less if everyone else goes down the tubes."

Sylvestre listens and learns. He knows now that the flowers that are worth so much money are also illegal. This frightens Gabriela and worries the villagers. It does not frighten or worry Sylvestre. What does he have to lose? What can they do to him that won't happen soon anyway? He clears more fields, grows more poppies, the padrone pays him more. He tells the padrone to grow no more coffee or cotton or sugar cane so the village men must work in the poppy fields with Sylvestre to earn any money. The villagers begin to envy him again as in the days when he was the boss of their finca crew, and he begins to despise them. Gabriela does not despise them, wants him to stop growing the evil flowers. She wants all to be as it was. She does not want him to be the boss of the village and be hated. The villagers want to tear him down, keep him as poor and ignorant as they are.

Sylvestre comes to hate the villagers more than they hate him. He wants to live as the yanqui padrone lives. He wants to learn about the world, learn all he has never been allowed to know. He wants to go away from the village. He asks the yanqui padrone to take him with him to where the padrone is always going. To El Norte.

"What about the village, Sylvestre?"

"It will never change. They will never listen to me."

"You wife? Your family?"

"They are as bad as the village."

The padrone smiles. "I think you'll do very well with me, Sylvestre. I think we can do good work together."

Sylvestre goes away with the padrone. He learns a great deal. He meets younger women. He lives in fine houses. He buys a finca of his own in the country far from his old village. He never returns to the village.

§

Three years old when her grandfather is sent to a labor camp on the coast for continuing to speak of El Presidente Arbenz after he is deposed by the generals, Dolores Rios is the last of ten children. She is five when this grandfather is killed by soldiers when he runs away from the camp and tries to return to the village from the camp. She cries for the man with the soft white mustache who played with her in the sun in front of the tin-roofed house while her mother worked the hand loom, her father cut wood to sell, and her brothers and sisters tended their plot of corn and beans near the mountain village.

When she is six she goes with her mother and sisters to sell weaving in the market town of Chichicastenango a day away. She sees her first norteamericanos. They frighten her with their strange sounds, but her mother and sisters rush to join the other villagers who surround the pale aliens. Her father sells his wood and disappears into a cantina with the other men until the sun is behind the mountains and it is time to return to their village. He is illiterate, her father, drinks too much, boasts

of all the children he has made and will make, but he is a hard worker and many village women envy her mother.

Dolores goes to the coast for her first harvest season when she is eight. Most of the village goes to pick cotton or coffee, to cut sugar cane, on the vast plantations of the padrones and the rich American companies. It is the only way they can earn the real money they must have in addition to the beans and corn to survive. But when she is ten the Indians of the Guerrilla Army of the Poor come to the district. The general who is presidente sends the soldiers to attack the guerrillas. It becomes too dangerous to go to the coast for work, there is no money, her father drinks himself to death.

At thirteen Dolores is married to an older village man. The new presidente, who sleeps with a norteamericano bible and a machine gun beside his bed, sends more soldiers and machines of war to destroy the guerrillas. The soldiers and war machines burn many villages and kill many villagers, the young men are taken by the army or run away so they will not have to be killed. Some go to the cities to find work where it is safer. Dolores has two children with her older husband who chops wood to sell like her father, works on the beans and corn like her absent brothers. She is fifteen when her husband is killed by a patrol of kaibiles who say he threatened them with his axe.

Her children die when she is sixteen. The doctor at the clinic in the market town tries to save them, but he does not have the skill or the medicines, tells her that in Guatemala, where a child dies every fifteen minutes, most women lose half their children to curable diseases brought on by malnutrition. She has been unluckier than most. Or perhaps luckier. One of thirty-two widows in her village where there are no men to marry and the soldiers do not let the families leave to earn money at the plantations on the coast, at least she is childless, can slip away one night to walk to Guatemala City. She is seventeen.

In the capital of the country there are too many people from the villages. Dolores has little money, at first she must live on the streets. Young and healthy, she soon meets a man who has a factory job and a clean shack only a little smaller

than her family's house in the village, finds work at night cleaning the offices of an American company in one of the tall, shining new buildings of the city. She walks home to save the money of the bus. The man she lives with, Hector, works long hours for not much money, drinks too much, and cannot marry her because he has a wife and children back in his village. But he is a quiet man even when he drinks at night while she is at work, gentler to her than most men she has known. With both of them working they can afford to buy enough food even after they send money back to their villages.

She has two more children. When the girl is born, Hector wants to name the infant Dolores after her.

"That was the name of my little girl who died," she tells Hector. "We will name her Josefina for my mother."

Hector understands. It is the custom to name the firstborn son for his father, but they had named the boy Venicio to honor Hector's brother. The son Hector has back in his village is named Hector.

Hector loves the children, stops drinking for a time and cares for them while she is at work. They make him sad, too, and when he is laid off from work, can't make enough money scavenging at the city dump, starts drinking again, she knows he will go back to his village. He cries, he does not want to go, but he has heard that life is better in the mountains now, he misses his family, she cannot feed them all on what she makes.

"You must find another man," he tells her when he leaves.

Dolores is twenty years old. She cries over Hector, then learns that two of her brothers are dead, her mother has lost their house in the village and remarried a man with ten children of his own. She knows that it is not another man she must find. She has two children, a home she cannot go back to, a job that has no future and can barely feed her children, and that she can lose any time for any reason to a thousand other illiterate women eager to take her place for less money. She will live the way she is for the rest of her life, will die at forty, and so will her children if they live past five.

A thousand miles north is a place where there is work and

they pay a week's wages for an hour. Where there are real houses and running water and sewers. Where children do not die every fifteen minutes, can live even eighty years. When Dolores has saved $400 by scavenging and begging in the day, has found two women whose husbands have gone north who will care for the children, she talks to a man who knows how to go north. She kisses Josefina and Venicio and walks from her shack and the city. She is twenty-two.

It is a long walk. She is offered rides by men who drive trucks, rural bus drivers, rich men with cars, and even villagers with carts and burros, but it is safer to walk and she will take a ride only if she can walk no farther. Once American tourists drive her all the way to Chichicastenango where she cries because her village is only a day away. She must hide whenever she hears a motor because it could be the police or a patrol of soldiers who will arrest her and send her to a model village if they don't shoot her as a communist when they find she does not live in the district, has no papers to say why she is walking north alone. She must hide from the guerrillas, they need women to carry and cook food, they are men too.

She has walked two weeks when the kaibile patrol finds her. The officer is a polite young man who orders his laughing men to leave her alone.

"My apologies, señora, but, alas, I must take you with us. I have my orders, this district is infested with the subversive communist rabble we are hunting, you would not be safe alone to continue wherever you are going."

They take her to a village. There are many other travelers the kaibiles have caught on the road, the silent campesinos of the village, and six battered and bloody guerrillas tied at the end of the single street. The young officer points to the sullen guerrillas to show her the danger on the road in this part of the country, puts her with the other frightened travelers. It is nearly dark when he returns to them. He tells them he needs help against the subversive guerrillas and the campesinos he suspects of concealing the communists and their supplies.

"We must know where these animals have hidden their

guns and their food, who works with them in this district. We must make them tell us what they know. I have a plan that will get them to talk to us."

He explains that he has threatened to shoot villagers and guerrillas alike, but the guerrillas don't really believe him. If they see him shoot all the travelers, they will believe he means what he says, and at least the campesinos will talk. He is going to take the travelers out to the edge of the village near the captured swine and have his men pretend to execute them. He wants the travelers to fall over and lie very still when his men shoot. He asks if they all understand? They nervously nod that they do.

"Good. Remember to act frightened, and lie very still. You will be doing much for your country, and afterward you can go on to wherever you are going."

The young officer smiles and calls in his patrol. There are more travelers than kaibiles. The kaibiles herd the villagers and prod the guerrillas to make them watch as the young officer steps up to put his pistol to the back of each traveler's head. When the first traveler falls he does not lie still. His feet jerk and twist. Dolores does not wait.

She is up and into the forest at the edge of the village before the kaibiles know what has happened. The others follow her. The villagers scatter. Only the guerrillas can do nothing. The kaibiles open fire, pursue, but Dolores has run as fast as she can, knows the mountain terrain well, and is not discovered hidden under a forest thorn bush in a deep barranca the kaibiles do not see in the falling dusk.

She waits in the forest all night. Hears the screams of those who do not escape, are shot on the spot. By morning the forest is silent, the soldiers are gone. She travels slowly in the forest for two more days before she returns to a road. She meets other women, and at the end of three weeks they are at the village near the border of Mexico where she is to contact the *coyote* she paid the man in Guatemala City to send her to.

She pays the coyote.

She wades a river.

She hides.

In Mexico everyone knows at once what she is.

"Hey, chica, you come live with me. I send for your children in Guatemala, eh?"

"Go back to Guatemala. We got enough troubles here."

"My brother is chief of police, chingada. You be nice to me or I tell him and they send you back!"

Two of the other women are raped.

"Catch that fucking chica, asshole!"

"Fuck her, Manolo, we got two live ones, who needs that one?"

She is hungry and cold.

"You need a coat, señora." He is an old Mexican with a fat, smiling wife and a small hacienda. "You must eat, sleep. In the morning you can continue your journey."

The coat from the good man and his happy wife keeps her warmer, but she is always afraid.

"You have money. Give us your fucking money, little hen."

"Shit, she ain't got no money. The coyote or the cops took it all. Cut her fucking throat."

She hides her money well. But not well enough to fool the rural police.

"We know you have money, chica. You want to stay in our jail until you remember where it is, eh?"

There are no more soldiers, but there are many police and many bandits and many men on the roads from the border. When she arrives three weeks later in Mexico City all her money is gone and she is afraid of everyone who looks at her. The city is so big, there are so many people. It is raining. The puddles are yellow in the streetlights. She is afraid to speak to anyone. They will know she is from Guatemala and send her back. She is afraid to beg or ask for food. They will put her in jail. She is afraid to look for the name and address she has been given by the women whose husbands went north. People will see her look, know she is not from Mexico even though she doesn't speak, put her in jail or send her back or rob her or rape her.

But if she does not find the name from Guatemala she will soon starve or freeze in the fog and cold rain of the city. Then it will not matter if she is robbed or raped or sent back. She must take the chance.

The apartment is in Azcapotzalco. The bright sun is out. Long ago Azcapotzalco had been a town with churches and graveyards and haciendas like the towns on the coast in Guatemala. Now it is part of the city, but the ruins are still there surrounded by the sprawl of a giant oil refinery and modern Mexico. The apartment is above a noisy cantina, but the woman from Guatemala can put her up until she finds a place, get her a job in the factory where the woman and her sister work. Five Guatemalans live in the three-room apartment. Dolores gets up in the dark, waits on the dim streetcorner with twenty others for the bus to the factory, does not make enough money to get her own place and still send money home for Josefina and Venicio. After a month she sees it is not that much better in Mexico. After two months she knows she must continue north.

There will be no kaibiles, but there will still be police and bandits and men. And *la migra.*

She must have a Mexican identity. To be caught by *la migra* and identified as Guatemalan will mean being sent all the way back. A Mexican is arrested and driven back to Tijuana to try again a day or an hour later.

She must lose her soft accent, learn the hard sing-song speech and slang of Mexicans.

She must have money. For the false papers in Mexico and in the United States. For the next coyote. For food and bus fare to the new border. That far even Dolores cannot walk. For good clothes that will avert suspicion when the bus is stopped by the Mexican police or immigration. To pay back the good sisters.

Dolores has no one to borrow from, will have to work, send no money home, until she has the money. It will be many months.

The sisters tell her they know a rich Don. A hidalgo from

home who lives in a magnificent hacienda in Cabo San Lucas where all the norteamericanos come to swim and lie in the sun and do nothing all day. This rich Don often helps his country-men to go north, comes often to Mexico City on business, has a party for his fellow Guatemalans at a big restaurant in the country outside the city. They take Dolores to the party at the restaurant that is in a great garden decorated like a fiesta, and she meets Don Sylvestre Madrona.

The sisters want Don Sylvestre to help Dolores go to the United States so she can earn money for her children at home.

Don Sylvestre wants Dolores.

This does not happen instantly. Don Sylvestre Madrona has many women at the party more stylish and sophisticated, better dressed and more dazzling than Dolores Rios. It does not begin until Don Sylvestre graciously agrees to talk to her alone in a corner of the garden. Dolores, who has worn her old Guatemalan huipile instead of the new Mexico City clothes the sisters have loaned her, is shy and scared and nervous and grateful that the Don will perhaps help her. They talk and Don Sylvestre promises he will help her, and she goes home with the sisters.

Next evening when Dolores returns on the long bus ride from work the flowers are waiting for her.

They are waiting the next day.

And the next.

Don Sylvestre himself appears on the fourth day. In his big white car with the driver. He takes her to a restaurant in the best part of the city. She is the only woman there dressed like a campesina. She is still scared and nervous, but the waiters are polite, the police respectful, important men friendly, and Dolores soon realizes that if she is with Don Sylvestre it does not matter where she works or lives or has come from.

The fifth day he arrives in a small red car that he drives himself, drives her to a country cantina far from the city, tells her that he will take her north to the United States personally. He wants her to come north with him. He wants her to come to his hacienda in Cabo San Lucas. He wants her. He is a

lonely man who will be good to her and give her money to send to Guatemala for Josefina and Venicio. He will give her money to pay the sisters who have helped her.

Dolores goes to the hacienda in Cabo San Lucas.

"I have many huipiles," he tells her when they are alone in the hacienda, "you will wear a different one every day."

She wears the huipiles for a month.

"Now you must lose weight," Don Sylvestre says.

Dolores loses weight, becomes thin and angular.

"You will be blonde."

Dolores becomes blonde with long loose hair like a norteamericana cinema star.

"Now we will go north," Don Sylvestre says.

He gives her a blue American passport. Her name is Dolores Shay. She was born in Los Angeles. They drive north in his big white car with the driver. At the border Don Sylvestre shows his papers and her passport. She smiles, the guards smile, and she is in the United States. They live in a fine apartment in Newport Beach, travel a great deal. Don Sylvestre takes her with him wherever he goes on his business except to Guatemala as if he is afraid if she sees her children she will want them. She does want them, but the money she sends is enough to pay her brother and his wife in Quetzaltenango to have Josefina and Venicio in the family, and Don Sylvestre is good to her.

Dolores does not know what made Don Sylvestre choose her, or why he brought her north and made her a thin blonde with cinema star hair and silver and gold clothes. She does not think about it.

She does not think about where he is when he is not with her. She knows he has other women, older women, but when he goes out to parties he takes her. He does not like her to leave the apartment when he is not with her, does not want her to find work or learn English or learn how to read. But he gives her much money to send to Josefina and Venicio, she learns some English by watching the television in the apartment all day, learns to read a little by watching a program on

Channel 34 where they speak Spanish, and Don Sylvestre is good to her.

When he is shot to death in Santa Barbara while they are on a business trip, she is frightened. She is alone in the hotel room, the police come and ask many questions she cannot answer. But they are polite, do not ask to see her papers, let her stay in the room.

Alone in the empty hotel suite, Dolores is sad. She turns on the television, practices speaking English with the faces on the screen, thinks that perhaps now she can get a job, even bring Josefina and Venicio to the United States. Or make enough money to go home and buy some land and build a little house for the three of them. Her dark eyes under the blonde hair stare at the bright faces on the television. She is twenty-five.

THE LION AND
THE MOUNTAIN MAN

DIANNE HEARS OF the young woman with two small children and a pony who goes door to door selling photographs of other children on the pony to proud parents. She decides this is an angle she can use as a teaser for the female business consultant she now represents, so she finds Nina Owen and makes an appointment to photograph her and the pony.

The female consultant is a new client and the budget is low. Dianne goes alone with her camera. Nina meets her in a trailer camp on Punta Gorda street in the *barrio*. The pony is tethered behind Nina's trailer. A thin, silent boy and a chunky little girl stand with the pony, carefully stroke it from time to time. The freeway is less than ten feet away through a high fence.

While Dianne is setting up her camera, a man appears. He's young, good looking, not tall but slim and lean in faded jeans and a heavy maroon corduroy shirt over a pale blue cotton turtleneck. He has a wide and boyish smile under a macho mustache, good shoulders, and a lot of interest in her. He asks about her camera, what she's going to do with the shots of Nina and the pony.

"Billy's my name," he tells her. He seems to think that is somehow important.

"Dianne." She smiles, and explains, "I do public relations. I've got a new client who advises women on business, and Nina's door-to-door pony and photo idea is an eyecatcher for an ad aimed at women going into business."

"Thought it all up herself," Billy says, grins at Nina.

Nina says nothing. She holds the older child, the boy, on the pony ready to be photographed by Dianne.

"About how much do you gross, Nina?" Dianne asks as she finishes adjusting the camera.

"I don't know. You almost ready? I got to feed the kids and groom Taffy."

"You don't have to hold the boy on the pony," Billy says. "It'll shoot better if you hold Taffy's halter, right Dianne? You don't mind if I call you Dianne?" He smiles again.

Dianne thinks, Oh God, aware that he is interested in her and not sure at all how she feels about that, especially while she's working with another woman. She looks toward Nina, asks silently, woman to woman, if this Billy belongs to Nina. But Nina doesn't seem to notice, is interested only in getting the picture-taking started and over with, and, later, in being paid. Once she has the fifty dollars Dianne agreed to, Nina takes the two children and Taffy and disappears into a ramshackle lean-to that seems to be where the pony is housed.

"You always do your own camera work?" Billy asks as he helps Dianne carry her equipment back to her car.

"Only when the budget is this low," she says, and laughs.

She hears herself laugh, knows she is flirting.

"Sounds like the countries I soldier for," Billy says. "Bring your own gun and uniform."

"What countries would that be? Aren't you an American?"

"As apple pie, and my lips are sealed." He laughs too. She wonders why people laugh so in sexual skirmishing. He is still talking. "Let's just say it's always hot and everyone except us paleface mercs is kind of dark-skinned."

"What do you do when you're not soldiering, or advising Nina how to pose for pictures?"

"Hey, that'd be telling." He looks around like a secret conspirator. "Actually, I'm a bunco artist, but keep it quiet."

"Bunco?"

"Sure, the big con, the scam." He grins that boyish grin. "Hey, you want a tip? If you want to run a safe con game in

Santa Barbara, a scam with no problems and no sweat, pull it off Friday morning an hour or so both sides of lunch."

"Why is that?"

"Anyone gets suspicious and calls the cops they get told to call City Hall. The fraud guy at City Hall's at lunch. So they call the public defender, only the whole office is closed for lunch. They try the Sheriff, the Sheriff don't have jurisdiction in the city. Better Business Bureau? Forget it, they send you back to the cops. The detective squad this time. They send you on to the D.A. Only D.A. Fraud is closed on Fridays, call back Monday! Half the town is ripped off before anyone's back from lunch."

Dianne is really laughing now, but is also aware that Billy sees this as his opportunity, the chance to make his move on her.

"Hey, how about we talk about it some more over dinner? Seven o'clock?"

She looks him over more carefully, from juvenile smile to good chest and slim hips and tight jeans. He's callow, yes, but he could be fun too. He talks big, and she wonders if he can follow up. Is he all hot air, or is there some power behind the smile? Then, he's so eager she's flattered. He could be a kick in bed, eager and boastful and gawky all at once. All need and drive and no technique. But that can be the best. She can teach him, guide him into what's best for her.

"Why not? Seven o'clock. Pick me up at my place, I don't like meeting in public. You have a car?"

"Hey, I'll be there panting."

They both laugh. She gives him directions and drives back to her office. The rest of the day she has doubts, but she knows those doubts. They are one of the prices you pay for being female in this society when you've agreed to do something a little daring, even risky. She has fought these doubts most of her life, so after work she goes home and gets ready. Not too dazzling or too feminine. Tailored jeans that make her seem taller than her five-feet-four, and a silk blouse to counter her sturdy build. Light blue and dark blue so she doesn't look too

eager. He probably won't even change out of his jeans, which is okay, he looks nice in them. She is ready when the bell rings.

But it isn't Billy who stands on her doorstep.

And yet it is. She is puzzled. It is a taller man, and older, yet he looks very much like Billy. He wears the same jeans, the same kind of turtleneck under a plaid shirt that looks a lot more expensive than Billy's shirt. Viyella. He is Billy with more solidity and without the juvenile smile. There is nothing juvenile about this man.

"Billy won't be coming," this man says. "You can swing your cute little ass somewhere else."

He turns and walks away. Just like that.

"Your ass is kind of cute too," she says to his back. "What do you do with it when you're not babysitting Billy?"

He stops. "Don't you ever ask their last names, Miss Krasnowicz? Mine's Owen. Just like Nina's. It's Billy's name too. Shazam, right? What a surprise. A married man. Not that they seem to care much, especially Billy, but I do."

"Why?"

Now he looks at her. As if she isn't what he had expected. As if this, what is happening, isn't what he expected.

"They didn't say anything," she says. "Either of them."

He walks back toward her. "What the hell did you think he was doing there with Nina and the kids?"

"I suppose I didn't think. Do you always? Whatever your name is."

"Frank Owen," he says. "Look, I guess it's mostly Billy's fault, okay? I talked him out of it so let's just forget it."

Again he turns to go. He is taller than his brother, broader in the shoulders and chest while still lean. Solid hips, and she guesses he's eight to ten years older than Billy. He fills his clothes better, especially the jeans. A lot of man in those jeans, as the girls used to say in high school. His face is more mature, creased in long sun and wind lines, and more handsome. He doesn't need his brother's macho mustache, moves with more grace than Billy. A man not a boy.

"Tell me," she says, "does Billy really do all those things he implies? The soldier of fortune?"

He turns once more. She almost smiles, but she doesn't. She knows now he isn't going to walk away again, but a smile could be the one action that might make him.

"Some of them," he says.

"What about you? What have you done wild, Frank?"

Then she does smile, challenging.

"Mostly avoid your kind of broad."

"What is my kind of broad, Frank?"

"A ball-breaker. Someone who goes after the easy mark like Billy. Gets her kicks and cheap thrills second-hand from married men."

"And you get your thrills first-hand, is that it? Step right up and take your thrills and kicks and whatever you want."

"Most of the time," Frank says.

They stare at each other.

"Why don't we have dinner and talk about it," Dianne says. "Someone in the Owen family owes me a dinner."

"With Billy you'd have paid your own way, probably his."

"All right then, I'll pay for the Owen I'm looking at. You interest me."

"Okay, so let's talk."

Frank crooks his elbow for her to take his arm. She laughs, gets her handbag, and they go out to his car. She is intrigued to see where Frank Owen will take her, is sure that with Billy it would have been a chain with big drinks, The Elephant Bar, if not a fast food joint. She has learned that where a man takes a woman to eat the first time tells a lot about him. From the way Frank has acted she guesses a steak house. Somewhere Frank knows the owner and bartender, where they greet him by name. Perhaps Harry's Plaza Cafe or Gallaghers or Joe's on lower State.

He does park in a lot on lower State, but they do not go into Joe's. He picks The Chalkboard, a small French restaurant owned by a man who had been chef at The Grand Hotel over in Los Olivos. It is one of her favorite restaurants. He is a more

complicated man than he seems. He likes good food, good wine. He's been around. That's the way he puts it when she asks. She doesn't let him get away with that.

"Don't give me the dropout roughneck act."

"What act do you want me to give you?"

"How about the real one? College, work, cities."

"Marriages?"

"All of them."

He tells her his family came from Nevada, he went to Eastern prep schools. He tells her about the Marines, the colleges, the teaching, the marriages, the children. She tells him about the West Pointer she married immediately out of college, and the divorce six years ago. The acting and modelling, and how bad she was as an actor and model. She tells him about the talent agency and then the public relations jobs, the PR and ad agency she owns now, and how she has always hated her name.

"What's wrong with Krasnowicz? A fine old Polish name. The melting pot. What are you, a snob? You want to be a WASP, have blue blood, eat sandwiches with the crusts cut off?"

"You're a WASP."

"Bite your tongue. Owen is Welsh. I'm a dark, brooding Celt. No effete, pale-faced Anglo-Saxon."

He is amusing, charming, they have a good time. Then it is the end of that first dinner. They have coffee.

"Tell me about your wives," she says.

He tells her their names, where he lived with them, when he was divorced, where they are now, and where he is now—alone and teaching in a private school in Montecito. It is not what she wants to know and she knows he knows that, but it is a first date and he has told her much. They have laughed and been open. She goes home with him to the two rear rooms he rents in a house on Humphrey Road which he calls the slums of Montecito.

They go to bed. His body is all she had expected it to be, and she seems to please him. He is lean and hard and not at all skinny, and his ass and shoulders and back feel good in her hands as he thrusts and she holds him in her. His hands feel

good on her back as he holds her under him so tightly she could not break out if she wanted to. His hand that grips her hair. His thrust. His long sound at the end. Savage. Mindless.

He sleeps and she lies in his bed and sees the lion again.

§

The lion lies in the high grass in the corner of her bedroom. It has a great black mane. Three females pace nearby. Cubs bite at their heels. She stands naked in the shadows of the jungle of her room. Monkeys and birds scream, snakes slide across her feet. She stares at the lion. It stands and she sees the tight sack of balls between its haunches, the wet penis extended and enormous. Swinging back and forth like a thick red rod as it walks massive toward where she hides.

She and her best friend Mariah have been to the football game. Mariah has whispered to Dianne that the second string quarterback is looking at her. He is a tall boy with long hair to his shoulders, a thick chest, tight pants with buttocks and bulge. A junior named Chino. Mariah's boyfriend, Greg, tells them later that Chino has asked who Dianne is. Greg says Chino isn't too swift, but if Dianne wants to they'll double date so she can look him over closer. Dianne says why not, and that night sees the lion for the first time.

Chino does not work out. The date is a farce. He is a dense lout who expects her to fawn over him, and at the same time is obviously scared to make a move on her. He talks big but does nothing, clings almost desperately to public places where he can be seen.

"You know how to make babies, Chino?"

"Hey, what talk is that. Listen to the music, okay?"

She laughs at him, ruins the date, and does not see the lion again for many years.

Her parents are older than those of her friends, a firmly conservative couple who bring their two children up to be what they are supposed to be. Her brother Max goes East to earn an MBA, join a large corporation her father's company

supplies with OEM switches, and return to be vice president in her father's company as they begin the changeover to electronics. Max is discouraged from marriage until he can afford a proper car, house, children, adequate insurance, and wife. Max dutifully complies.

Dianne also complies. As a girl, she does not go East. She attends a small local college, is encouraged to find a nice young man immediately after graduation. She will raise a family, sail serene at his side through a smooth life. It is a plus if she chooses a husband who can join her father and brother in the family business, but this isn't mandatory, her father is not a martinet. She is expected to choose soon, even before her graduation, so the wedding can actually be announced at the commencement as her mother's was. A double sign of her success.

She chooses a young man she's known for years in church and community, who's been away at West Point. The last two summers they have seen much of each other. Richard is steady, reliable, and believes what their parents believe. He is not handsome or especially tall, but he isn't ugly and he has a fine future in or out of the army. He is also about to graduate, the families approve, and so they are married.

They spend the first two years in Texas. She fits in well with the other army wives. They are people like her parents, have the same views of such things as the tragedy of Vietnam when the army wasn't allowed to win—when the country betrayed its own soldiers—and the new Communist threat in Central America. But it is hot, and dull, and in their second year in Texas she finds the rigid structure, the narrow circle, the elitism, stifling.

Later, she knows that the change didn't begin with any of those things, but with the total male orientation.

"Boys get to do what they want, girls pick up after them," one of the older wives says. The view is not welcomed by the other officers and wives.

Richard is what he is supposed to be. Elite, patriotic, hardworking, dedicated. He serves his country, the rest of the world is *them*. Civilians are *them*. In the officers club minori-

ties are *them*, except the few who are officers and so different. He is a disciplined lover. At least twice a week at bedtime or after a party. She learns that women, too, are *them*.

"Why can't women be line officers? Go into combat?"

"Where do they sleep, Di? Go to the john? We live in the open. When they get their period, do we stop the war? What happens if you're captured? If the enemy rapes you, gets you pregnant?"

"The enemy does things to men. What's so bad about getting fucked? It happens. It's a risk we take. At home or with the enemy."

"You think we want our wives fucked by enemy soldiers?"

The third year they are posted to Germany. She is excited, eager. Richard has his first independent command. Germany is new and different. Richard works hard: a bastion of his country on the front line.

Its black mane like a dark satanic halo, the lion moves through the moonlight reflected from the deep snow of the forest outside the leaded windows. She is naked. Her heart pounds. Spears and battle-axes hang on the walls. Her eyes are wide as he looms over her. The swelling balls in the dark pouch between its corded leg muscles. The long, wet, red rod as thick as a tree branch that swings before her. He blocks out the light. On her back her legs spread wide. Open, wet, her hips thrusting. She moans, writhes, slashes her nails into raw hide, bites as his thick, pulsing rod tears her open, fills her.

They have gone on holiday to the Black Forest. In civilian clothes Richard is smaller. It is winter, the snow is deep. He wishes he were back on duty. She knows this and he spoils it but not so much that she wants to leave the dark, medieval aura of the forest and the villages and the Gothic churches and almost hidden castles. A forest that has not changed for thousands of years. The same forest where the barbarian tribes swarmed out of shadows to massacre a Roman army. Vandals, Goths, Franks, all hair and furs and horned helmets.

The old church is deep in the darkness of the trees. Smoke drifts across the snow-covered land. The light is thin through

stained glass in the gloom of Gothic arches. Somewhere monks chant plainsong that takes her back a thousand years and more. The song and their footsteps echo from the stone and hollow spaces. She understands religion. The medieval need. The weight of darkness, of ignorance, the ultimate weight of no control, of helplessness. In the forest death is tomorrow, death is every day, death is now—sudden, arbitrary, without cause or explanation. The answer is religion, and then death has no horror. Men who die without reason kill without reason. No guilt, no immorality. Kill as a bear kills what moves across its path.

Outside the church, in the snow and dark trees, she wears a heavy robe of skinned animals. The trees are thicker, the dark heavier, the faint odor of smoke fearful. She is alone and lost, fears the smoke but finds it. A shaggy man and two growling dogs huddle over the small flames. The man motions her to the fire. She crouches in the warmth. He hands her hot meat. She eats. She lies down. He takes her. They sleep in the furs. Two men appear from the forest. They spear the man at the fire. One of them grabs her. She bites and kicks. The other man laughs. The men fight. One cuts the head off the other with a single axe blow. She lies down for the winner, opens her legs. They cut up the bodies, feed them to the dogs. At dawn they take the furs and the weapons and leave with the dogs.

The lion stands in the path of moonlight from the sea to her bedroom. At her high window she looks down at each muscle etched by moonlight, corded with power. She raises her arms and her breasts swing and point. The curve of her belly hollows, thrusts out the mound below with its dark hair. The bull slashes into the moonlight, hooks its vast horns. The lion roars. The earth shakes to a clash by night. Raw wounds open in the grass, trees fall, the night itself is trampled, ripped. The bull is gone. Her flesh is hot, she cannot breathe, her thighs and the wet opening wait for the triumphant lion.

Richard decides on a military career and after another year they return to Texas. Dianne is no longer like the others. She does not fit in with the wives who are like her parents. Richard still does what he is supposed to do. Richard will always do

what he is supposed to do. It is what he wants to do, second nature, part of him. She joins a local theater, looks for work, talks to the army wives about their rights. The older wife is not there any longer, the other wives call her a feminist and stop asking her to lunches. She wants to change them, ruin their smooth lives. She wants to annoy their men, hurt the army, destroy the country.

By now she can't imagine why anyone would want to join the army, male or female, but she fights for the right of a female to join the army. She joins a feminist protest at the gates of the Texas base. The Colonel's wife talks to her. She tells the Colonel's wife that the army, the country, and the Colonel are sexist, that women have a right to do anything and everything. The Colonel talks to her himself.

"When a man is fighting for his country, Dianne, he needs to know his woman is backing him up at home. Doing her part."

"I am doing my part. I'm fighting for women. I need to know my husband is backing me, doing his part."

"Feminist views are disruptive. Bad for the army."

"So I shut up?"

"You aren't helping Richard's career."

When she joins a protest for the rights of Mexican squatters on army land, Richard seems to know it is time for a divorce before she ruins his career as well as the smooth lives of the other wives and the country.

"We don't think alike anymore, Dianne. You've changed."

"You don't think, Richard. You'll never change."

Dianne moves to Los Angeles and tries to break into movies or any other acting career, become a professional model. She does not have the talent for acting or the face and body for modelling, has become strong enough to know that and face it. She goes into the talent business with a large agency, soon opens her own talent agency. When the irresponsibility and ego of actors become a bore, she branches into public relations. She finds she is good at PR, adds advertising, and soon is a full-fledged business woman. The next step is to move her agency to Santa Barbara, devote it to handling female

owned and operated firms, and break with her parents who have barely spoken to her since the divorce.

There are many men after she leaves Richard. Affairs and liaisons and companionships that last from weeks to months and once almost all year. One-night stands. Weekend flings in the mountains and beachhouses. From-party-to-his-place passions. After-meetings-to-her-place unwindings. Blind dates. Even a pickup or two. It is fresh air after her parents and Chino-the-substitute-quarterback and Richard. All seem necessary at the time, none leave any memories or regrets. Not even the one that lasts almost a whole year.

His name is David, he is in charge of advertising at one of her client companies when her office is still in Los Angeles. He asks her out many times, but she always has someone else who is far more interesting. Until they meet at a convention in New York where she knows no one, has no personal contacts, and lets him take her to dinner and the theater. He knows New York well, they have a fine time for the next three days. He isn't handsome, or tall, or athletic, or especially attractive. But he is intelligent, humorous, knowledgeable, admires her a great deal and knows how a free and independent woman wants to be treated. After Richard, and the men since Richard, he is wonderful to be with.

David has never been married, living with her is a totally new world for him. He dotes on her. A female is a miracle to him, a discovery, a whole new landscape. He delights in her, can't get enough of looking at her naked. He is a gentle lover, but strong enough and constant. Every night she will let him, that is. He won't force her, not ever. He is patient and always ready, but it is up to her. She learns much more about advertising from him, but he never puts his work before her unless it is an emergency, and then he makes up for it with dinner out or a weekend in Puerto Vallarta. He helps in the apartment, cooks as well as she does.

She leaves him after the year.

She has many reasons, the main one being her desire to move to Santa Barbara, but she has to tell him there are other

reasons or he would come with her, commute the ninety-odd miles to his company.

"I've just fallen out of love, David."

The physical attraction has gone, the excitement has faded.

"It happens, David. I'm sorry."

No one's fault, the chemistry simply changed and left them friends but without the passion. She needs to be alone for a time. She needs to look for the passion that will last. There may not be any such passion, but she has to at least look.

"You too, David. You deserve more than I can give you."

He is devastated, but accepts her decision. He returns to his total devotion to his job. But he has come to know the beauty of a woman and less than a year later she hears he has married a real estate woman he met a week after she moved up to Santa Barbara. She laughs when she hears this. Poor David.

She enjoys doing what she wants to do without having to worry about what anyone else wants. One of her new activities is the Montecito YMCA and aerobics. Still in her twenties, she has been too busy to notice her body except in bed. Now she notices a faint thickening, and short and sturdy as she has always been she can't take any thickening.

The aerobics class is almost all women, but sometimes there is a husband or a boyfriend. The men are usually older, late forties to sixties, and there is usually only one at a time. The older women defer to him, the younger women smile and giggle as the man does the aerobic steps. The instructor both smiles and defers, is always pleased to see him. Men are diffi-cult to get to come to a class of women.

Sometimes there is more than one man. If the new man is younger, the older man begins to do all the exercises he has rested through or skipped when only the women were there, matches the younger man. If the new man is older, then the man already in the class works just enough harder to show he can do more than the newcomer. If they are both young men, then both do more than is required by the instructor, the exer-cises and moves only the youngest of the women can do. Dianne realizes that this is only in a class where all the others

are women. In a class of all men, it would happen only with the "leaders." The other men, those who had already acknowledged the "leaders," would not have to do any more than they usually did.

The tread of the lion shakes the earth. She is filled with fear. She is filled with need. She sees her cubs from the great lion. They have its haunches and mane and whipping tail, her face and breasts and slim belly. She licks her dry lips, opens her legs as she does every night when the earth shakes. He breaks into the dark bedroom all yellow eyes and fangs and towering shoulders and tight testicles and the enormous long thick wet red rod that will fill her no matter what she does.

§

Dianne gets up and dresses. Frank Owen comes awake, sits up. He sees it is still dark. Only twenty minutes have passed since they rolled apart, exhausted.

"What's wrong?"

"Nothing's wrong. I'm just going home."

He lights a cigarette, lies back and watches her. "Why?"

"Because that's what I do, Frank."

"Always? Slam, bam, thank you Sam?"

"Not always." She slips on her shoes, stands. "I have my business to run. It has to be something more for all night."

He nods. "Okay. I'll drive you home."

"I already called a cab. I didn't want to wake you."

"I'll call you."

"I'd like that."

She leaves, not at all sure he will call, and making herself not care as she has always done. She won't be a man's playgirl, not since Richard. She is a woman with a full life of her own. Yet she listens for the phone. Do men listen for the phone? They probably do, but she'll never really know. This time the phone does ring. He has L.A. theater tickets. His odd combination of convention and rebelliousness pulls her. The educated freebooter, mental outlaw.

In bed that night they talk of men and women, of his wives, of Richard. It has been another good night, she is tired and sleepy but she will go home and now he knows it. He has a sheen of sweat on his chest and belly, in the pubic hair where it has pressed against her wetness. He begins to talk about his past women. Really talk.

"It was a kind of dream with my first wife. We were going to be together forever, you know? Then it started to change. I was always doing what I didn't want to do. She had what she wanted. Husband, house, kids, friends. I needed more, something different. She couldn't be different. My second wife couldn't either. Maybe no woman can."

"Some can, but the man has to be different too. Richard was everything he was told to be, and he expected me to be the same. I was a sex partner, the comfort waiting back home. Women can't be just sex objects."

Frank lights a cigarette. "You *are* sex objects, there's nothing you can do about it except cut men's balls off so we won't need sex at all." He shakes his head. "You can refuse to be the sex object of a particular man. You can deny him and his needs. You can refuse a sex relation between you and a specific man, but unless you create a world of eunuchs you're a sex object to all men."

"All right," Dianne says, as she gets up and starts to dress. "But I have to be a lot more than that to one man. If all he sees in me is what every other man sees, then I'm nothing to him. I may not be able to stop being a sex object to all men, but I can stop being only a sex object to *my* man."

She is dressed and comes back to the bed to bend and kiss him. She kisses his chest, his belly, the wet penis in its hair.

She leaves and he does not try to stop her.

The next days she does not listen for the telephone. She knows now he will call again. It is three days, she does not know where he is, but then he calls. There are no tickets this time, no courting dinner in a special restaurant. They go straight to his rooms and drink beer and make love. After, he tells her about his father.

"He killed himself when I was ten," he says in the dark, his eyes up to the ceiling, his hand touching her mound. "They'd been fighting, him and my mother. They'd fought as long as I'd been old enough to remember. He never did anything. Hunt, fish, cash the checks his brokers sent, drink and gamble, tell dirty stories with the boys, and chase other women. What kind of life was that for a man? A man was supposed to do something useful. A man was supposed to carve out a career, be *someone*."

His hand goes on slowly playing with her mound, her pubic hair. She says nothing, waits for him to tell it in his own time, his own way. It is, she senses, important to him.

"She never understood him. She would have to have been a different women. He hunted, and fished, and gambled, and drank, and flirted with every woman in town *because* he had nothing to do except make money, provide a husband for her and a home for me."

"Not Billy?" Dianne says, trying to be gentle.

"Billy wasn't born. I'm not sure he ever knew about Billy. Maybe he did. Maybe it was knowing about Billy made him climb up on South Gorge, sit there from noon to sunset, then light a cigarette and step off into the river two hundred feet below."

She waits and watches him as he lights a cigarette, smokes, puts his right hand back on her wet mound.

"Only it wasn't Billy. It was her. It was El Dorado. He'd never had a chance to go and find El Dorado. He'd never gone, and he suddenly knew he never would."

She doesn't know why, but that night she stays. That night she decides she will sleep there, and in the morning he is up first to make juice and coffee and his special pancakes. Thick buckwheat pancakes, the way his father had taught him to cook them over a campfire in the high mountains. He uses that exact phrase: ". . . over a campfire in the high mountains."

She enjoys the buckwheats. He is pleased. He doesn't have to be at his school until ten, sits and watches her get dressed for work.

She says, "Why do I feel something just ended instead of beginning? Why do I feel I've betrayed myself? Why do I feel you're going to run screaming? Why do I hear a train whistle, a jet engine, see vapor trails coming out of your ass? Why do I have this sense of a vacuum where your chair is, an empty space?"

He eats the last buckwheat, carries his dishes to the sink, rinses them.

He says. "You're different. Maybe you're even different enough. I won't fake anything."

"Neither will I."

"I'll pick you up after work. We can talk about it."

"We can talk about it."

"It might really go."

"It might," she says, and goes out to her car.

She knows it won't go. He will always see the campfire, taste his father's buckwheats in the mountains. She will leave him, and he will call whenever he passes through town in later years, and she will see the lion in the night and flop on her back and open her legs. Until they are both too old to see the lion or the distant campfire.

MARRIAGE & DEATH, SOLITUDE & CONFUSION

"Why do you want to make this tape?"
"Because I want to help other people. I want to help them face death. I want them to know about me. . . ."

HE FISHED AT THE EDGE of the surf. The sea washed up to his knees. Gulls screamed beyond the breakers. A swirling cone of gulls, gray and white above the blue water in the hot morning sun.

The gulls were still fifty yards down the beach when he saw his line would wash in before they reached him.

This, the relation between his line and the seagulls, was important. The location of gulls is a significant factor for all surf fishermen. The gulls, too, are fishing. Feeding on schools of small bait fish. And down beneath the bait fish are larger fish, the predators, also feeding on the bait fish, and it is among these larger fish that a surf fisherman wants to place his bait and his hook.

He reeled in rapidly and cast again.

To cast the surf you must concentrate all your weight and power behind the sweep of the long pole. If your line breaks, you fall into the waves.

His line broke.

Dripping, he stood and watched the sinker sail far out

trailing the broken line. The gulls swept past, and he turned up the long, hot beach toward his gear.

In Salt Lake City there is a monument to the miracle of seagulls a thousand miles from any ocean. A great Tabernacle dwarfed by mountains, and slum shacks surrounded by a vast, flat desert.

> *"You know you will live until your tenth birthday?"*
> *"Yes, because I prayed to God to live until I was ten. . . ."*

The man behind the desk in Salt Lake City offered him the job. He told the man he would have to think about it. The man was confused.

"If you didn't want the job, why did you fly all the way out here for an interview?"

He had another appointment for an interview in Dallas. He walked east out of Salt Lake City toward Dallas. Drivers offered him rides. Sometimes he took the rides, sometimes he walked most of the day. The motels were all the same. He met strangers in the taverns. The woman in Santa Rosa, New Mexico, wanted only whiskey. He spent all his money.

A thousand miles from Salt Lake City the truck turned off into a side road across the desert and disappeared through the dust hanging in the hot air. The truck driver had fought in the Pacific in World War Two, told tales of whiskey stills in the jungle, of the girls in Australia thirty-five years ago. He did not ask the truck driver for money.

He sat at the side of the highway.

A distance of flat hills and cactus, the sun glare of a white sky. The shimmer of stones. A lizard.

> *"And after you are ten?"*
> *"Then I will die. Because I would like to die and live again somewhere else. . . ."*

65

In the long miles of the island summer colonies break the empty dunes like settlements on a frontier. Settlements returned in winter to the dunes, deserted to the gray surf and the abandoned dogs.

He climbed a high dune to eat his lunch.

A chaotic pattern of hot red garnet streaked the dunes and ancient spiked grasses. At the edge of the sea a litter of beams, hatch covers, cork, seaweed, small skeletons, and rotted refuse. Pools of thick black oil from ships that passed far out unseen. A narrow island of blowing sand and prehistoric grass sibilant on the summer wind. Fragile barrier between the heavy sea and the shallow bay, slowly disappearing in time and hurricane to rise again somewhere else.

He ate his lunch alone on the dune and listened to the surf and the distant gulls still feeding.

The wake of her outboard motorboat reached back to the mainland across the narrow bay in the afternoon sun. She ran the boat up into the underbrush of the island.

He finished his lunch and watched the sea to the south that reached unbroken past Bermuda to the ice of Antarctica.

"Had enough?"

She dropped down beside him on the high dune.

He cleaned his reel after its immersion in the sea.

"Not yet."

Propped on one bare arm, her dark hair blew loose in the summer wind. Gently.

"Why did you come over here today? Saturday afternoon?"

"I came to fish."

"You never fish on Saturday afternoon." She traced a circle in the sand with her finger. "You didn't come over here to fish, you decided to fish to come over here." Intertwined circles in the shifting sand. "You don't want me here, do you?"

"I want to fish."

She was a tall girl, big-boned and not at her best in a bathing suit. At her best in a slim dress. Out of her dress and naked. In a half light, full and beautiful.

"Everyone's over at the Tavern."

He wiped the sand from his reel.

"It's still early."

She sat up, looked back across the bay toward the cars moving on the mainland.

"What fun is Saturday afternoon alone?"

He oiled the reel.

> *"Why have you decided you want to die?"*
>
> *"Because I am so sick. When you are dead and a spirit in heaven you don't have all the pains. The pain is in this world. But, sometimes, if I want to, I can visit this life. I can't come back into my old life, but I can come on a visit. . . ."*

Baked beans ooze thick from the can. Steam rising sweet. The piece of pork not good to eat. For flavor. Eat it now. Soft, fat, thick . . .

He piled stones beside the highway.

Tall cactus trees.

He looked for a real tree. One . . . two . . . two . . .

Land without trees, jagged.

He walked.

A black and yellow land that rolled like a sluggish sea.

A bridge that crossed no water.

He sat on the railing of the bridge.

Rock and sand. Bridge over a ragged wound in the earth where nothing flowed. Neither blood nor water.

He walked.

Bare shacks held by the fist of the desert. Fenced dust and gates without paths. Gray porches that sagged in the heat of the sun. Fenced dogs to bark at a passing shadow.

Beyond the last fence and final dog the highway again.

And a diner.

Peeling paint. Gasoline pumps. Cars ringed like lions at the odor of food.

"You believe in reincarnation then?"
"Yes. I want to come back a healthy boy. I
don't know why I chose to come into this life sick.
When you come back, you don't remember why
you chose it the way you did. . . ."

She watched his hands on the reel as if trying to understand the need to take apart a fishing reel, as if some answer were there.

"Is it going to be us, or something else?"

He fitted the reel back together.

"I'll fish a few more hours."

She sat with her back to the sea.

"I don't care where we live. Salt Lake City, Dallas, here. They have hospitals everywhere. I can always get a job until we have children. After I finish working on the tape with the boy's mother. We think there's a real book in it, his story. He was so young and so mature. His doctor says his acceptance of death was special. Such insight for a little boy. You never know what you'll learn in a hospital. I don't care what hospital I work in. If we live here the house near Tom and Marie is perfect for us. Big enough for a family for maybe ten years."

He fitted the reel back onto the long rod.

"It's a good house."

Her hands smoothed her thighs. "You didn't go out west for those jobs. I don't know why you went away. It made me unhappy."

He tied a rig to his line.

"I came back."

She watched the mainland. "No you didn't. Not yet. When you come back we'll be together."

"We were together last night."

"No," she said, "not together. I want to be together. There's no one here. Just us. We have to decide."

She walked down the high dune to a shadowed hollow between two dunes. She lay down on the hot sand. He set his rod into its sand spike, went down to her. He lay close against her. Her hair blew across his face. Her red bathing suit lay on

the sand. Her hands moved light across his bare back. Her flesh was thick, heavy, warm on the soft sand in the shadows. Under him. Sun on his back, hot. Wind blew the sand among the empty dunes. Over them and between them, an island of hot, liquid sand and heat and shadows. Moving. Silent.

A single cloud moved high and alone across the high sky.

> *"You really remember what the other side looks like?"*
>
> *"I think I can give you an exact example of what it looks like. It's sort of like you walked through a wall into another galaxy. It's like walking into your brain. You have left your body, and are living on clouds, and your spirit is there. . . ."*

He buttoned his shirt. He licked his hands and wiped them clean on his pants. He smoothed his hair.

The man behind the diner counter was burned the color of dark leather.

"I don't have any money. I'm going to Dallas."

The counterman leaned both hands flat on the counter.

"So?"

"I haven't eaten since Santa Rosa. Three days."

"Nice town Santa Rosa."

Doughnuts and danish pastries on the counter under plastic domes. Two customers ate hamburgers and drank beer at the counter. Working men in stained clothes. An older man in a gray suit with a blue striped tie ate at a table. The waitress read a magazine in a booth.

"I'm hungry," he said. "I'll send the money."

"So ask."

"What?"

"Ask me. Go ahead."

"Can I have something to eat?"

"That's it. Go ahead."

"Can I have a hamburger?"

"That's all?"

"A glass of milk," he said. "A piece of pie?"

"Good! Go on. Tell me how you want the burger."

"Medium rare. With cheese. A cheeseburger and french fried potatoes. Some pickles. Lettuce and tomato. Blueberry pie. With ice cream. Vanilla. À la mode."

The counterman slapped the long counter. Grinned all around at the two working men, at the older man who went on eating, at the waitress. The waitress closed her magazine and giggled. The counterman winked at her. The corner of the counterman's mouth twitched as if with a tic.

He watched the counterman's dark face. "Two scoops of vanilla ice cream. Toast the roll for the hamburger. A bottle of beer. Maybe two. Coffee with plenty of cream. Four spoons of sugar. A bowl of soup before the burger."

"Tell me what you gonna do for it?"

"Wash the dishes. Sweep out. Clean up the kitchen. Scrub the floors. Wash the garbage cans. Take out the garbage."

"I got a dishwasher. I sweeps out myself. I got a Indian for the garbage and a Mex scrubs the floors."

He nodded.

"You better send the money like you said. So go on, what else you want I should give you?"

"Could I have a glass of water?"

The counterman roared with laughter. The two working men at the counter laughed. And the waitress. The waitress laughed louder than anyone, the counterman was her boss. The older man at the table looked up but didn't laugh. The counterman wiped tears from his eyes. He stopped laughing. The waitress turned back to her magazine. The counterman moved three cooking hamburgers in their fat on the griddle.

"Shit, give him some water."

The hamburgers bubbled spitting over a low flame, there for any customers who might suddenly walk in and be in a hurry. The counterman prodded the hamburgers on the griddle as they cooked down to nothing. Soon they would have to be

thrown away. The counterman turned them viciously. A stain of sweat darkened his shirt between his shoulder blades.

"Don't ask me I should cook."

"No."

"Take a sweet roll. Helen, bring the guy a glass o' milk. Make it two sweet rolls, you got a long walk to Dallas."

The waitress carried her magazine, read as she walked. She set the milk down on the counter without looking at him. He thought about throwing the milk and the two pastries at the counterman.

"So eat," the counterman said.

He ate. The milk was cold and clean. He thought about throwing the second danish at the counterman.

"Don't take all goddamn day," the counterman said.

He ate the second pastry.

"What the hell do you say?"

"Thanks," he said. "Thank you."

> *"Why do people fear death so much?"*
>
> *"Because when you are dying you are so afraid and you hurt so much. You want to hang onto your body and not leave with your spirit. If you don't hang onto your old body, let yourself ease away, it's not so painful. I will be glad to be a spirit, leave this body, so I won't be afraid. . . ."*

Water washed up to his knees. A solitary beach dwarfed under the towering blood-purple sky of sunset. His long rod like the antenna of some insect.

The fish struck.

The twilight vibrated to the struggle between land and sea. His tools functioned inevitably, drawing the fish from the sea to the sand. A weakfish. Sea trout. Flashing blue and orange and silver in his hands in the dying light. Empty fish eyes. He placed the fish under the water at the edge of the surf and watched the quick swirl of sand where it vanished.

71

He climbed the high dune to light a small fire and sit beside it as the last light faded to the west and night moved in. Night that is cold on the island even in summer. The sea close. The dunes high and black.

The distant sound of a jukebox from the mass of mainland light across the night. They would all be there with her. In the tavern. In the cars. On the open tavern deck looking out toward the dark island. They would dance to the music of Saturday night.

He smoked on the dune until the fire died to embers.

Oars grated in oarlocks out on the bay. The sounds and voices of two boats that moved closer to the island.

He gathered his gear and crossed the island through the sawgrass and wild cranberry bushes. The beach party passed on the main trail from bay to ocean. Among the bushes he waited until they had gone on over the last sand ridge and down to the beach and sea where they would build a large fire and sit drinking beer and singing old songs and, later, hold hands to disappear into the grass and dunes.

At his boat he loaded his gear and pushed off. He rowed easily on the shallow bay. On the island the beach party fire began to leap up the shadows of the night. Figures outlined on the dunes like distant savages.

> *"I would like to be buried in a garden of flowers. I will be put into a box first, and then into the ground in the cemetery, and I will have a little garden of flowers over me. My own garden I can see and smell. . . ."*

The older customer came out of the diner. The screen door slammed metallic, echoed across the distance of the desert.

"Did he get to you?"

The old man held out a package of cigarettes.

"A little."

The old man lit both cigarettes.

"A simple man, the counterman," the old man said. "He means no harm, really. He believes the rules he found waiting for him, the restrictions and the pleasures. He honors the accepted, grants importance to that which was important before he came onto the scene."

The old man offered him half of a ham sandwich.

"Thank you."

"The counterman isn't bad as countermen go in West Texas. I eat here often now that I'm alone." The old man considered the sweep of the desert, the distance of the empty highway. "Few care to transcend their time and place. They simply want the most from their moment. You were a pleasant diversion in the day of a counterman in a diner in West Texas. A man who goes to bed with his waitress, drinks with his friends, hunts with his cronies, and supports his wife and children. He wants all a counterman in West Texas can have, and a bit more than the next fellow if he has the chance. You were an unexpected bonus, made his day."

"Something different, a little fun."

The old man said, "You're not from out here. An Easterner?"

"I had a job offer in Salt Lake City."

"Did you take the offer?"

"No."

"And decided to walk all the way back to the East?"

"To Dallas. See the country. There's a job opening in Dallas too. There was a woman in Santa Rosa, New Mexico. She liked whiskey. I spent my money."

A king snake glided across the edge of the desert toward the garbage cans behind the diner. Where there was garbage, there were mice.

"I'm going into Abilene," the old man said. "You can get a bus to Dallas. You can send me the money."

73

> *"I don't want to be cremated. I don't want my*
> *ashes scattered. Because when you are cremated*
> *you can be accidentally stepped on by someone.*
> *Someone could think I was only wood ashes, that I*
> *wasn't there at all. . . ."*

His house was quiet and dark between two that blazed with light and sound. He put away his tackle, and sat down in the night on the steps of his house.

Over the noise of radios and television sets, motors rising and fading on the highway, he listened to the sounds of the night itself.

He cooked a can of vegetable soup, mixed in some clams he had dug from the mud of the bay, and cut a loaf of bread.

He wound the line from his reel onto the line dryer his father had built when his father had taken up surf fishing in his old age. He cleaned and oiled his reel again. From a spool of nylon gut he cut and tied five leaders.

In the library of the small house the books stood on the shelves. The records stood in racks. The bottles of wine stood in the corner niches. His father's house.

"What we do. Books, music, wine," his father told him, "to just hold them in my hands."

He took down a book. He held it cool and smooth in its glistening dust jacket. Blue and orange and silver in the dim light of the small house.

> *"I have been waiting to die for a long time. I*
> *am too sick to live on in this body. I wanted to live*
> *until Christmas. Then to next Halloween. I want to*
> *live now until I am ten. Then I will die. I will*
> *leave this body and have a new body. After I am*
> *ten. Perhaps eleven. . . ."*

The sun dropped lower behind to the west as the old man drove east toward the darkness over the desert ahead.

"You expect to take the job in Dallas?"

He could feel the chill of night coming to meet them.

"No. I'm going to be married soon. We've been engaged for some time. We've got our house all picked out. She works in a hospital. There's a boy in her hospital dying of leukemia. She got close to the boy and they made a tape recording. She played it for me. The boy says he's seen heaven and lived here on Earth before. He believes in heaven and reincarnation and spirits. My fiancée's very excited about it. He's only ten years old. Just ten, and dying, and wanted to tell his story to help the world. My fiancée says he's an exceptionally bright little boy, she thinks his story will make a great book. A message for all of us, you know?"

The old man took a silver flask from his pocket. The old man drank, wiped his mouth.

"Conan Doyle wrote an historical novel, *Sir Nigel*. Some English archers capture two French spies. The fourteenth century so it's death on the spot, but the archers have some fun. They make the spies run for a woods a hundred yards away. One spy runs as fast as he can straight for the woods. The archers let him almost make it, then shoot him down easily. They laugh. Triumphant, and proud of their skill.

"The other spy runs slowly, looks back every few seconds. The instant the archers shoot he dives to the ground and all the arrows pass over. Before they shoot again he's up and in the woods. The archers cheer. They're sports, he's beaten them fair and square. But the spy makes a mistake. Sure he's safe in the woods, he stands up to taunt the archers. He laughs at them. The best archer makes a spectacular shot right through his throat and kills him. Now the archers really cheer. No one can get away with mocking a good English archer."

The sun was gone behind, the desert changed in an instant from day to night. The old man drank again from his flask.

"When I was a boy I loved that scene. I read it over and over, as triumphant as the archers. It was thrilling, exciting, even funny. It would teach that spy a lesson. It was a very good joke. I'm over seventy now, and the joke isn't there anymore. The thrill isn't there, or the triumph. I don't think now about

those heroic archers, I don't think about that victory. I think about the spy in the woods. I wonder what he thought when that arrow hit him."

The land ahead emerged from emptiness and lizards into scattered trees and the lights of unpainted houses. Into the outskirts of a city.

"What did the spy think in those woods?"

The old man drank. "Nothing. The book had ended for him. There was no book, it didn't exist for him. Maybe it never had existed."

He saw the glow in the dark sky ahead. He looked out of the car at larger houses with brighter lights. At factories and floodlights. He saw the streets and traffic lights of Abilene.

"My father was excited by books and music. Just to touch and hear." He watched the lights of the busy Abilene streets. "Did you ever hear the *Concord Sonata*? By Charles Ives? My father said it might be the greatest piece of music written in America. Or Roy Harris's Third Symphony. Both beautiful, powerful, unique. Nothing else in the world quite like them. But in the end, will it make any difference that they were ever written?"

The old man found the bus depot, bare and flickering neon on the Texas back street. He took the old man's name and address so that he could return the ticket money, and rode the bus from Abilene to Dallas. From Dallas he flew back to New York on the ticket he had bought before he came west. In New York he called her. When he got home that night he took her out to dinner. He asked about the boy in the hospital.

"He died three days ago. His mother told me his acceptance of death was same at the end. She asked him if she could get him anything, but there was nothing more he wanted—except that he wanted her to stop talking for a while. She said he smiled when he died, as if he already saw heaven again."

She ordered shrimp and crabmeat in a special wine sauce, and had brandy with her coffee.

"His mother asked me to the funeral. She told me how

much he'd liked talking with me in the hospital, how important to him it had been to make the tape, tell his story. He'd picked the place for his grave himself. He liked it because it was between a big tree and a large rock where they could plant the garden of flowers over him the way he had planned it. Where no one could step on him as if he wasn't there."

In the morning he took his fishing gear and rowed over to the island to fish at the edge of the surf.

> *"Some people will cry because you lived only ten years. How do you feel about that? What can you tell them?"*
>
> *"That it is all right. I have lived before. In many places. I will come back again."*

From his house to the crossroads the road was a shadow flow of cars toward the light and noise of the tavern. Loudspeakers above the tavern doors blared their invitation to dance.

She was there in the noise and smoke. Waiting among the swirl of faces like a priestess in a temple. Tall and a little heavy in a green dress, her eyes reflecting the blue and orange and silver of the juke box. She reached up to touch his face.

"I'm glad," she said.

For an instant he could not find himself in the long bar mirror. Then he saw the reflection of his face smiling over her shoulder.

TALKING
TO THE
WORLD

IN MEMORIAM:

ARCHIBALD JOHN DOUGLAS LYNDS,

1886-1952,

who lived both the dream and the nightmare.

> **THOUSANDS OF GOOD
> AND BEAUTIFUL AND ADMIRABLE
> SPECIES OF ANIMALS AND PLANTS
> HAVE PERISHED
> BECAUSE THEY HAD TO MAKE ROOM
> FOR OTHER AND STRONGER SPECIES
> AND THE VICTORS IN THIS STRUGGLE
> ARE NOT ALWAYS THE NOBLER
> OR MORE MORAL FORMS**
>
> —ERNEST HAECKEL, 1900

As he came in, Carl Warren nodded over his shoulder toward the apartment next door.

"What's with those crazy signs, Dan?"

Dan Calder had been fascinated by the hand-lettered signs in the window of the next unit since the first day he came to look at the apartment. He couldn't explain why, but the signs were a large part of what made him want the two-floor duplex despite a freeway and its constant traffic noise only fifty feet away. At this critical time in his life he had enough on his mind, and one apartment was as good as another. He didn't care where he lived as long as it was close enough to the zoo. But the signs in the next door window had made this particular apartment special.

"That's Mr. Joachim. He's an old man lives alone, keeps his bed in the living room, watches everything that happens out-side. He makes the signs on big sheets of white cardboard with a housepainting brush. Some of them hang in that window a day, some over a week. I guess it depends on how much he

likes them, when he feels like making a new one. I'm collecting all the quotes."

It had taken Dan a long time to make the decision to give up his private small-animal practice and take the chief veterinarian job at the zoo. But he took it, and after that everything seemed to happen at once. The disbelief and recriminations, the rage and anger, the doubts. The arguments and the ultimatums. In the end, there was nothing else he, or his wife of twenty-five years, could do. She could not accept his decision for a new life, and he couldn't continue to live what he'd come to see as a hollow life, a lie. He moved out of the big house in the Valley, she filed for the divorce, and he found the two-bedroom duplex in one of the cheaper parts of town close to the zoo.

He hadn't lived in an apartment since before his marriage when he worked at a riding stable back home and helped out at the zoo when they needed him. It was, in a way, a full circle, the twenty-five years of his marriage like a long sleep, the life of someone else, and he moved into the new apartment in the large L-shaped complex in a rundown neighborhood near a freeway. The front apartments faced the streets, the rear apartments looked out on the parking lot, and the first thing Dan saw when he came to make his application to the owner were the big, bold signs displayed in the window of the apartment next to the one he was applying for.

"What the hell for?" Carl Warren said. "I mean, what are they all about? He selling something? Pamphlets maybe?"

"I think he's just talking to the world."

"It's crazy. Who sees them, you know? Who cares?"

Warren was the night man at the zoo. He was filling in for Dan while he moved into his new apartment, but one of the koalas that arrived only a month ago was giving them trouble, and Warren didn't feel he could handle her by himself. Dan wanted, needed, some time to adjust. Time to understand what had happened, what he had done, and exactly how he felt. Time to get to know the old man next door and the other tenants in his new life. Time to settle into the apartment and inside himself. But the koala at the zoo had begun to act strangely

even before he left the Valley, and Carl Warren came to get him again late this afternoon while he was still unpacking.

"What was she doing? When you left, how was she acting?"

Warren hunched with his hands in the pockets of his windbreaker, and shrugged. "Nothing, you know? Not a damn thing. She never does a goddamn thing, Dan."

"She eat at all?"

"A little." Warren looked out the open windows at the parking lot of the apartment complex. "This ain't much like what you're used to. Twenty ratty cats fightin' in the garbage, a beaner kid smoking pot on the roof over the fence, and some skinny broad painting the goddamn whitewalls on a pickup?"

"It's close to the zoo, easy to take care of, and cheap. They'll leave me alone, my former poodle patients' owners won't be looking me up here. All things I need right now." And he grinned at Warren. "And the signs. I like them, they *are* crazy. Now, tell me what else about the koala?"

Warren shrugged again. "I had to hand feed her."

"She throw up? Look sick? Hide?"

"Just hanging on a branch. Moping. Got her back turned to the people. Who knows with a koala? I mean, hell, they're cute and all, but they sure don't do much."

Koalas had always been among the hardest animals of all to read. They clung in their solitary silence to their branches and stared expressionless. Inscrutable. Motionless most of the time, slow motion when they did move. Both timeless and somehow out of time. The koala Warren had come about was one of five shipped to the zoo directly from Australia a month ago. A young female, she had been named Jane when she arrived. At the zoo they wanted an exotic name to lure the American public. Someone suggested Tanya, and someone else Tondelayo, but no one could accept a Russian or African name for an animal that looked like a solemn teddy bear. Then they noticed there was something aloof and haughty about her, almost regal in her dignity. Cool and remote like a northern princess.

They named her Ingrid.

She and the other koalas became the jewels of the zoo, especially for the children, and especially Ingrid. Her sense of distance, her indifference to attention, appealed particularly to the adults. Almost human, they said. A silent movie star. Greta Garbo. Until Ingrid's aloofness turned out to be based on more than dignity or arrogance.

She started to lose weight. First a few ounces, then a pound—a tenth of her body weight. Everyone was told to watch her closely, and the director told Dan to make her a priority. He began to stay late, sit with her in the perpetual twilight inside the koala cage. Koalas are nocturnal, move slowly through the night in the far Australian outback where she had been born. Ingrid moved almost not at all, a silent shadow on an unseen branch in the dim evening light.

Alone with her in the twilight of the cage, he realized he was not alone. The other koalas hovered all around in their silence, and they were real. People. She, Ingrid, was someone he had to deal with on her own terms, according to her needs and hopes and values. She was not one of the pets of the last fifteen years he never really knew because he did not deal with them but with their owners. It had been like treating slaves, puppets, stuffed dolls. He had always had trouble with pet owners. Not the lonely old lady with her cat, the solitary dog lover. For them the animal was a real person too. But for most the pet was their sense of power, their dominance, ownership, tyranny. The animal wasn't real the way they were. Nice to have around, decorative and even comforting, but disposable.

"All right, I'll get dressed and follow you back."

"How about a beer?" Warren said.

"In the refrigerator. Help yourself."

He pushed the heavy boxes of books and records into out-of-the-way corners of the living room, put away his lunch dishes, gave up any more idea of settling in that afternoon, and dressed in better clothes for the zoo. By the time he got there, tended to the koala and whatever else came up, and returned, it would be too late to unpack anymore. Too late to do anything except go to bed so he could get up at seven with half a hope of

making it through a full day tomorrow and still have the energy to unpack again tomorrow night.

"Landlady she don't allow no motorcycles."

The manager of the apartment complex stood outside his open window. A tall, raw-boned blonde, her arms and shoulders had a thickness that could only come from years of physical labor at some earlier stage of her life. Framed by thin shoulder-length hair, her small face could have been pretty once, but her mouth had grown tight, her nose narrow, and her eyes as flat as a pit bull. She wore the sturdy shoes and flowered print dress of a proper matron, but had the ramrod bearing of a drill sergeant. Outside Dan's window, she stood with her hands clasped behind her back, her unblinking stare fixed on Dan.

"It's just Carl Warren," he said. "The night man from the zoo where I work, Mrs. Anson. He came to get me. An emergency with a new koala."

"It don't matter. No motorcycles in the parking lot. You better tell him to get it out of here."

"He's having a beer. We'll go when he finishes. I can have visitors, can't I?"

"Don't make no difference to me," the manager said. "Only they come on a motorcycle, they leave it out on the street. That's the rule."

"He'll be going right out," he said.

"See he does then."

§

The owner, Mrs. Stockman, had had his application laid out on the kitchen counter in the empty apartment when he'd come to look at it the final time, to measure for what furniture he could bring from the Valley house. She stared down at the application from time to time as she asked the routine questions. She explained first month, last month and cleaning deposit, and finally got to what was on her mind.

"You make that much money at the zoo?"

"I'm chief veterinarian."

"Chief?"

"It's not as grand as it sounds. There aren't a whole lot of Indians over there, but, yes, chief I am."

"It's like a doctor, right? You have to go to college and all? Where'd you go?"

"Like a doctor," he said, "if you're a horse or a tiger or a gorilla. I graduated from Cornell. That was some time ago, I'm afraid."

"Tigers and gorillas?" the owner said. "I never knew we had any tigers or gorillas in our zoo."

"Sorry, just a figure of speech. No, no tigers or gorillas. Not yet, thank God. I plan to start slowly this time, tigers and gorillas come later."

"You just started being a veterinarian? What were you doing?"

"I meant starting again on large animals, Mrs. Stockman, exotic animals. What was I doing? Being the usual Valley pet doctor. Poodles and pussycats."

"That's how come you have a house in the Valley." She looked down at the application again. "With a house in the Valley, why would you want to live down here?"

"I'm getting divorced, Mrs. Stockman, starting a new job. New job, new life, new home, right? I wanted to stop pampering the owners of healthy poodles and try to get back to something more useful. Something I was trained to do. Something more meaningful." He sat on the edge of the counter in the empty apartment talking, he knew, as much to himself as to the landlady who really didn't care about the story of his life but only how much money he made, why he wanted an apartment in the slums when he had a big, expensive house over in the Valley. She wanted to be sure he was a serious applicant for her apartment. "I know that sounds a little pompous, but I need to do something more than I've been doing. Something with large animals again. Work with real animals that might justify all the years of study and training I put in a long time ago. My wife had other ideas for our future. Or her future."

"*What is it with you, Dan? I really don't know. I mean, what have you wanted all these years we don't have? Did you*

want to live alone? That'd be news to me. You certainly seemed to like your regular fuck well enough. Are you so misunderstood? If so, then your parents haven't a clue either because they think you're as sick as I do. You don't like a nice house, a good car, the top-of-the-line clothes, your beloved VCR, the vacations to exotic places? You gave a pretty good imitation of liking it all these years. I know you like your daughter because you've waited until she was in college, and I know it's not a woman because I've had it checked. Tell me. Make me understand."

"I want to do something worth doing."

That was when the rage came. "You're telling me our life is nothing? Our life isn't worth doing? The whole world wants our life. Don't you stand there and try to tell me my life isn't worth anything. I have everything I worked for, everything anyone could want and more."

"I don't have what I want."

She stared at him as if he were some alien creature, the enemy. "I hate you. Get out of my house."

"I'm sorry. About the divorce, I mean," the owner, Mrs. Stockman, said, and looked once more at his application. "I suppose you don't need a big, fancy place now you're living alone. And the zoo is pretty close too."

"Then I get the apartment?"

"If your references check out, it's yours. I don't get a lot of professional people down here."

<center>⸎</center>

You went to the manager, Mrs. Anson, to pay your rent, make complaints, report problems. The problems and complaints were entered in the manager's log book in triplicate. One copy for you to prove you had reported or complained, one to remind the manager to get the work done, and one for the owner when she came to pick up the rent checks.

"Come on in then."

A large flowered couch faced the door on the far side of two ornate coffee tables. Another couch, in a different and

clashing floral pattern, formed an "L," faced the kitchen and dining area. A color television stood on one of the coffee tables. Flowered armchairs, heavy wooden sideboards and chests, carved tables, a complete dining set of oak veneer for the dining area filled the rest of the room. Two refrigerators and an upright freezer crowded the kitchen section. A microwave oven stood next to the electric stove. Living room and dining room sets, matched, in colors that complemented the carpeting. Heavy flowered draperies matched one couch and two armchairs. The drapes were closed even in the warm afternoon.

"Yeah?"

In the shadowed room, the manager sat eating from a bowl of popcorn. A bright, excited voice talked to an unseen audience. The television light flickered across her hair and expressionless face.

"My upstairs bathroom sink is leaking," Dan said. "Mrs. Stockman said I should come and report any problems to you."

"For the book. You sure you ain't done nothing to that sink?"

"I'm sure."

"You did, plumber'll find out, and then you got to pay the repairs."

"My innocence will be vindicated, Mrs. Anson."

"I guess we'll find out."

She heaved herself up off the couch, walked briskly into the kitchen area without once bumping into the mass of furniture crammed into the small space of the apartment. A child crawled on the floor, the thickness of a diaper inside its pink corduroy overalls. Dan smiled at the child, crouched down so it could see him up close. It stared unblinking, as silent and solemn and motionless as the koala at the zoo.

"Cute, ain't she," the manager said as she crossed the room without looking at the child. "You got kids yourself, Calder?"

"One girl. She's up at Berkeley."

"What kind of work she do?"

"She's at the university."

"Guess that means she's a smart one, right?"

"I hope so."

The manager found the book, thumbed through for the last entry. "Landlady says you're gettin' a divorce."

"That's right."

"That's the upstairs sink?" She opened the book on the heavy dining room table, licked the point of a pencil stub. "In the bathroom? A leak?"

"Right."

She wrote laboriously with the stub of the pencil.

"That university your daughter she goes to, it costs a lot o' money, I guess. You got to be doin' pretty good for living down here."

"The University of California, Mrs. Anson, it doesn't cost that much. Kate works part time too."

"You mean us taxpayers pays for it?"

"And you all have my thanks."

Her writing was slow but firm. Determined.

"Landlady says you got a big house over in the Valley."

"My wife has now."

"Some kind of doctor?"

"Veterinarian. I work at the zoo, I don't need a big or expensive apartment, I like it down here, I expect to stay quite a long time."

"How bad? Fast or slow?"

"Slow. It's not really a bad leak, I can live with it, but it'll damage the floor pretty soon."

The manager wrote in the book, pressed down to make sure the triplicate copies came out.

> THE DESTINIES OF MAN
> ARE INCOMPATIBLE WITH
> A UNIVERSAL PRINCIPLE OF BENEVOLENCE
> OR WITH
> WHAT IS TO SOME DEGREE CONTRADICTORY
> A UNIVERSAL PRINCIPLE OF JUSTICE
> DARK, UNFEELING AND UNLOVING POWERS
> DETERMINE HUMAN DESTINY
>
> THE NEW INTRODUCTORY LECTURES
> —FREUD

A different quotation in the same bold black letters whenever Mr. Joachim got around to making a new sign to display in his window. Large letters made with a broad brush and house paint on sheets of white posterboard while he sat up in bed in the living room and listened to his music.

Music that came through the wall into Dan's new apartment with the impact of a distant drum. A giant drum and the weight of an enormous shadow. A shadow that settled behind Dan's eyes like a black horizon without trees or mountains, that moved and spread as wide as an interstellar cloud as he listened.

"Mahler," Mr. Joachim said.

A small old man, brittle and yellow, Mr. Joachim sat propped up in the bed with the posterboard, cans of black paint, brushes, books, papers, and writing pads scattered around him. The color television set that faced the bed was always turned on without the sound. The state-of-the-art stereo played through speakers set high on facing walls, and

the bed stood like an island in the middle of the all but empty living room.

"You live next to me," Mr. Joachim said. "You work at the zoo. A professional man with a college degree and a house in the Valley but you wanted to work with tigers and gorillas and your wife didn't like that so you had to become a hermit and live in the slums. Our landlady is impressed."

"Why do you have your bed in the living room?"

"Cancer tires you out quickly. I like to be near the desk, my books, the stereo, the radio, and the television. Modern reality. I like to read by the sunlight, and work sometimes on my notes. I can watch the people pass and see them as they read my signs."

"You only play classical music?"

"Only."

"Mahler?"

"I like Mahler. I like many composers. Mostly German, I admit. We all have our conditioning, our prejudices and myths and parochialism. There are Russians, too. A little English and American and Mexican, Latin America. Maxwell Davies, the unknown Havergal Brian, Ives, and Revueltas. Italians, only some opera. Bellini. Middle and late Verdi. French nothing. Except perhaps Berlioz, and in the soul Berlioz is German. Never apologize for what you like or don't like."

"You're German?"

"Prussian. A Berliner. A long time ago."

"You're not Jewish, Mr. Joachim?"

"A Jew, no. Jewish, maybe."

"What do you mean? Jewish, not a Jew?"

"My family were taken away. Auschwitz, Dachau, Buchenwald, Belsen, somewhere. There were, of course, records, but they were destroyed at the end of the war. Theirs, mine, many people's. I was nineteen when the zealous Nazis came to save us from filthy godless Bolshevism, weak Wall Street capitalism and aristocratic imperialism, and restore us to the old values. My mother went to her church on Sunday, my father did not go to church. We had many Jewish friends. No one ever said

what my father was, it never came up. It was not important to him or to me. We were Prussians. He had served the king and the Kaiser in and out of the military. His father had revered Bismarck. There is no record of what Bismarck thought of my grandfather. We had lived in Berlin and Potsdam for generations. If somewhere far back there had been an Isaac in the Frankfurt ghetto, it was of no importance to my father except, perhaps, to admire the skill and industry that had gotten said Isaac out of the Frankfurt ghetto. It was, however, important to Hitler, and, perhaps, in the end, to my father. He vanished into a railroad car to Buchenwald or Auschwitz or Treblinka. I was sheltered by a Lutheran family of my mother's cousins since she had gone wherever my father had gone. The cousins, too, were staunch Prussians, and religion sat lightly upon them. We lived in the country, raised food, worked at our jobs, read Kleist and Fontane, Goethe and Schiller, did nothing in any way special before or during the war. Few did anything special. Of those who did, there were a remarkable number of Prussian names we learned to our pride later: Moltke, Tresckow, Schlabrendorff, Bussche, Trott zu Solz, Lehndorff, Yorck von Wartenburg, Kleist, Schwanenfeld, Stauffenburg, and two von der Schulenburgs. They died as Prussians, and we who could not emulate them could aspire and honor. They failed, but, then, no one ever rose against Napoleon in his own country. I grew up a Prussian and an atheist. I do not believe in God. So, not a Jew."

On the TV, violent, panting, unshaven men ran and screamed and shot at each other in some half-dark alley in some gaudy television city that could have been that same Berlin before the death trains and the smokestacks. The different Berlin of today after the death trains and the smokestacks.

"People won't like that," Dan said. "A lot of people in a lot of places wouldn't like it."

"Most people." Mr. Joachim switched off the gunbattle in the dark alley. "Get me a Coke, Mr. Calder. Take one for yourself."

"Can I hear something?"

"Something?"

"Some Mahler."

It took a long time to finish. Mahler, not the Coke. The music had that same deep shadow that filled his own room on the other side of the wall and rested dark inside his chest. Inside his whole body. But hearing it close, not through the walls, the massive music carried him somewhere. Into a past and into some future. Into a different space where he felt sorrow and despair, and yet peace and even exaltation too.

"What do you call it?"

"The Second Symphony."

He thought about the Second Symphony of Gustav Mahler. "The first time I had a job I really liked, a job I wanted to do, it felt something like listening to that. After college and vet school, when I found a job where I could work with horses and help at the zoo. I felt the way I do there at the end. When a sick animal gets better I sometimes feel like that. When I took the job at the zoo this time."

"*The Resurrection*," Mr. Joachim said.

"I thought you weren't religious?"

"That's what he called it, Mahler. *The Resurrection* Symphony. It was a different time, a different century. Would you like to hear another?"

"Are they all that long?"

"Mostly. Some are longer, three are shorter. What he felt, Mahler, you couldn't rush."

He listened to Mr. Joachim's music, and watched the dark screen of the silent television. Enormous singing. Mahler's Eighth Symphony. He recognized the Latin from the church when he was a boy. A cathedral soaring high and vast all around him. He thought of Australia and the long horizon of the outback where the koala, Ingrid, had been born.

"Because a man is born a Jew must he want to be a Jew?" Mr. Joachim popped his fresh Coke. "Must he desire the Jewish ethos, the Jewish picture of the world? The Jewish culture? Only that, excluding all else? Because a man is a Jew must he love only, or even, Jewishness? Is it not permissible for

him to want to be a Prussian? An atheist? Is each man obliged
to defend the accident of his birth? Must we all be what we are
supposed to be? What others tell us we are? Can I not declare
that I am what I feel I am, what I say I am? Decide my own
label? Because you want me to be a Jew, then I must be a Jew?
Must I be what you can understand? Must I always and forever
defend the part against the whole?"

The music still sang in a soaring chorus. A thousand mas-
sive voices in, now, German. He drank his Coke. Listened to
the explosion of voices. Heard the heavy shadow of the music,
and saw the small shadow of the koala on its solitary branch in
the silent dark of its cage.

> *. . . Blicket auf,*
> *alle reuig Zarten!*
> *Blicket auf! Blicket auf! . . .*

§

THE MANAGER ON THE TELEPHONE: "You got some
visitor parked in apartment E's parking space. Apartment E he
works late, he got a new Ford Escort wagon. He got his private
space in back like everyone else, 'n he don't like leavin' the car
on the street in front outside his apartment at night. So you tell
that visitor he got to park out on the street."

"Sorry, Mrs. Anson. She'll be leaving soon."

"None o' my business when your lady friends leave, only
she got to park her car some place else."

"I'll tell her before she goes, Mrs. Anson."

"Tellin' ain't gonna do apartment E no good when he
comes home."

"I said I'm sorry. Next time she'll know, it won't happen
again."

"Next time ain't what we's talkin' about."

He held the receiver. "You mean you want her to go out
and move it now?"

"Don't care what she does or who moves the car long as it
ain't in apartment E's space when he gets home."

In his dark bedroom the woman from the zoo office lay and watched him where he sat up in the bed. He held the receiver and studied it for a time.

"I'll move it, Mrs. Anson."

"Right now."

He hung up, and got out of the bed. As he dressed to go down he had a vision of the manager seated inside her dark window waiting for him to appear and move the offending car. He saw her hand still on the telephone receiver in case he didn't appear within ten minutes.

§

Smaller than her mother, the manager's daughter was a dyed redhead on the edge of anorexia. Her jeans were too tight, and her black leather biker's jacket too big. Her voice was three times louder than her size, and she laughed when Dan walked past her to the laundry room.

"Hey, how's it going by the zoo? I got to get over there, right? Like this weather it got to be made for goin' to the park 'n the zoo. Great day, Dan, right?"

There was no man at home in the manager's apartment, but the manager took care of the crawling infant, and the daughter never went anywhere alone. Endless girlfriends came and went all day and on into the evenings, and on Friday and Saturday nights, the men. Girlfriends from the neighborhood, and different weekend men who all wore T-shirts rolled up over their biceps and drove pickup trucks. They brought six-packs, the men, and went out in packs with the daughter and her girlfriends.

The daughter had her own pickup truck. A dark green and white truck she washed every week in the parking lot outside the fenced concrete patio of the manager's apartment, with the truck stereo turned on full. The latest music. Loud and pulsing all day through the whole complex of twenty-eight duplex apartments.

"Mrs. Stockman says we need a lot more classy tenants like you," the daughter said, cocked her head and red curls. "You

really make all that kind of money? Like, you went to some kind of graduate school and all that?"

"I work at the zoo, Ms. Anson. That's all. A plain old veterinarian."

"Call me Cass. Cass and Carrie, the hot-shot Anson girls," she giggled. "You're married but you got no kids. That why you want a divorce? No kids out of her?"

"I have a daughter. Up in Berkeley."

"Whatever, right? I got a kid. Hey, don't ask, right? That's what they say in New York: *don't ask already yet!* Least she got me out of high school. No one could take those creepy teachers. 'What do you do at home, Cassandra, obviously not your homework.'. . . 'Perhaps you should put your mind on other things than boys, Cassandra.' All the time tryin' to get inside my little lace pants out behind the gym. They even used to call my mother to come down and talk! What a laugh, Carrie goin' down there to talk to those wimps. Some of the women they even come to the wedding. Pinch nose 'n tight ass creeps."

"I didn't know you were married."

"Hey, what do you think? Sure we got married. I mean, Ray was a good guy, you know? It's just, hey, after a while we knew we wasn't in love, you know, 'n there ain't a lot of work in this town. Least, he left me the truck. A good guy, Ray."

Her joy, the truck, its windows and bumpers adorned with stickers: NO ONE TRUCKS LIKE I DO . . . YES, AS A MATTER OF FACT, I DO OWN THE WHOLE DAMN ROAD. . . I LOVE MY TRUCK . . . I DON'T GET MAD, I GET EVEN . . . KEEP ON TRUCKIN'. She spent hours washing the truck. Whole days squatted down in front of the washed tires, tongue out between her teeth, with a can of white enamel and a small brush painting the raised lettering that proclaimed the name, make, and sporty style of the tires. Painted the wheels and covers white. The strip of whitewall on the tires. To the shattering beat of the car stereo booming through the neighborhood.

§

He got into the cage with the koala, Ingrid, and tried to coax her with some especially good eucalyptus leaves. She clung to her branch and stared at him. When he tried to force her mouth open, she backed awkwardly down the trunk of the tree and walked slowly off into a darker corner of the perpetual artificial twilight inside the cage. A shadow of dignity and sorrow, the millennia of her species. After a week, all he could do was take her out of the public exhibition cage and put her back into the dim isolation room behind the koala quarters where she had first arrived, and where she now hung listlessly on a branch.

"How's it going, Mr. Calder? With your koala, I mean? Is she going to be okay?"

"No one seems to know, Mr. Binder."

Binder lived in the apartment behind his with a succession of small, shy, silent women. A big, heavy man with a paunch and a slow, ponderous gait, Binder seemed to roll his way through the passage to the laundry room instead of walk, and was an animal lover. Pets weren't allowed in the complex, so Binder had no pets of his own. He had his silent women, and made pets of each stray who wandered into the parking lot. He fed the strays, talked to them in the evenings out in his small concrete patio.

"Stick to the women, Herman," the manager said. "Cats is nothing but trouble around here."

"So? Women are not trouble, Carrie?"

"Get on with you, Herman."

Mrs. Anson thought Binder was a card, a real man.

"He's a hell of a man Herman, ain't he? All them women!"

There were stray cats all over the neighborhood. Scrawny creatures who found the large garbage containers of the apartment complex, designed to be picked up by special trucks, irresistible sources of the regular food they had never found anywhere else. The manager called the city animal control department and had them trapped. The traps were cylindrical cages baited with food, and animal control took the cats away. There were always more, and the owner didn't want cats in the garbage, so the manager called animal control regularly.

97

"Hey, them cats is too small for you anyway, Herman," the manager giggled.

"Hey, Carrie, you big enough?"

"Too big for you!"

They slapped each other.

"Hey, maybe not. Want to try?"

"I'll let you know when, Herman."

"Don't wait so long you maybe miss the ride."

"You don't need me, Herman, you got them cats."

They always laughed together over Binder and his stray cats, the manager and Binder. They had their constant circling dance with each other, like a pair of stray cats themselves, until Bill arrived. Bill was different, became a source of trouble and no more laughs.

Bill barely looked like a cat. His color was perhaps a muddy brown shading to gray mottled with a dusty black. Thinner than his own shadow. His coat had no nap at all, like a cheap fur collar worn for years by a street wino. There was no certainty he was even a Bill. His ears were hairless, his tail sparse and ragged as if shaved by a dull knife. His bones showed sharp through his matted hair.

He appeared one day, Bill, walking slowly, and wouldn't eat Binder's food. He sat silent across the parking lot and looked at Binder. It was obvious he had never eaten cat food. Binder went to scraps. It took Bill a day to approach the paper plate and slowly begin to eat. He left half the food, as if he'd really forgotten how to eat. Or at least how to eat like a cat. As if it hurt him to eat.

Binder saw it in a different light.

"He don't care," Binder said. "He don't care if he eats or not. He's sayin' he ain't got nothin' to eat for."

Bill was too smart to be trapped, or too indifferent. That made Mrs. Anson angry. It was a personal affront that Bill couldn't be trapped, an insult to the apartment house owner, Mrs. Stockman, and herself. An outrage to property rights and her, Mrs. Anson's, job.

"You stop feedin' that one, Herman," the manager said.

"He got to be dirty 'n diseased, 'n God knows what the hell else. He got to go."

"You can't trap him, Carrie," Binder said. "He don't want nothing, he don't need nothing. He don't want to be warm, or safe, or maybe even stay alive. No way you gonna put this one in no cage."

"Everyone an' everything wants something, Binder. They all wants everything they can get. Even a no good half-dead cat like that one."

§

After some late night beers one night in Dan's apartment, the zoo director went to leave and found his car blocked in the parking space by a new light brown Ford Escort wagon that had been parked out in the center of the lot directly behind it. The director had parked in the space for apartment E where Dan had forgotten to tell him not to park. Dan was able to move his own car out of his adjacent space giving the director enough room to maneuver around the Ford and get out.

That left the shiny new Ford wagon parked alone in the middle of the blacktop parking lot like an island, with its assigned space empty in front of it. Dan returned his car to his own space, but he couldn't move the locked Ford. He had to leave it out in the lot as ridiculous as a boat high and dry on a beach, or a car abandoned in sudden flood waters.

Some time later the sullen young husband came out to move the Escort wagon into his now empty space. His jaw was rigid, his back stiff, his furious eyes implacable on Dan's door.

§

Heavy branches of an avocado tree in the back yard of a Mexican family hung over the fence into the apartment parking lot in cascades of broad green leaves and dangling fruit the tenants of the apartment complex liked to pick from the ground when they fell, or, sometimes, jump and pull off. The Mexican family didn't mind, there was more than enough for everyone, and the tenants in the apartment complex had come to depend

on the tree for their guacamole and salads, took the fruit as part of their lives.

The landlady did not view this situation with the same equanimity. There was the question of proper ownership, of responsibility and liability. The parking lot was certainly hers, the yard where the tree grew belonged to the Mexican family. The fence, however, had been put up by the people the owner had bought the place from, and belonged to the apartment building. But who did the overhanging branches belong to, and, therefore, the fruit? Clearly, everything on this side of the fence was the landlady's. Consequently, it had to be that the branches and fruit hanging over the parking lot belonged to the landlady. Good for the tenants, but not good for the landlady. The dropped fruit was messy, the fallen leaves and twigs had to be swept up and disposed of.

The manager swept the grounds each morning, patrolled the entire parking lot. She examined the back fence for loose boards between the apartment parking lot and the Mexicans' yard. She tested the gates in the fences around the small concrete patios in front of each apartment, picked up blown paper and fallen branches and the crushed fruit of the avocado the cars had run over before anyone could pick it up.

Vigilant, she marched determinedly along the fences and around to the front to sweep any debris into the streets, returned to give a final sweep around the rear flowerbeds, especially those under the overhanging avocado branches where the brown leaves collected. She always looked up with a certain annoyance at the spreading branches of the avocado, particularly if that morning it had dropped leaves or fruit onto the parked cars of the apartment tenants. Many of them, including the landlady herself when she came to collect rents, and the solemn young husband of apartment E, complained about the fruit dropping on their cars. The young husband always swept them off his light brown Ford Escort wagon, and often hurled them back into the Mexican family's yard beyond the fence.

The manager also took any fruit or large branches she

found on cars or in the parking lot and threw them back over the fence into the Mexican family's yard. But her real anger was reserved not for the overhanging branches or the fallen fruit, but for the dark-eyed, silent and nameless older son of the Mexican family.

The Mexican youth had his bedroom on the second floor of the frame house on the other side of the fence. He often climbed out his window to sit on the flat roof of the back porch to read, watch the sky and the clouds over the city, and stare into the distance. But sometimes he sat instead on the slope of the steeply pitched main roof of the house, his foot braced against a ventilation pipe, out of sight from the street out front or his own backyard, and smoked.

The manager stood in the parking lot, hands on her hips, head cocked and outraged. "Right out in the goddamn open! You see him up there? That's marijuana he's smokin'. Not even hidin' hisself behind the tree. Just don't want his folks or anyone on the street to see. Like if a cop goes by, right? The rest of us, he don't give a shit."

"It could be just a cigarette, Carrie," Herman Binder said. "Maybe he just wants to be alone, you know? Maybe his folks don't like him smoking."

"That's marijuana and we got laws against that. Them and their damned tree."

One morning when the young Mexican was smoking alone on the side roof, the manager went back into her apartment and called the police. Then she sat at the open window of her apartment and waited.

The dark young man was gone from the roof by the time the police arrived, but they tramped over the Mexicans' house and the roof anyway looking for evidence of marijuana. The manager sat in her window and watched. The police found nothing, left after a stern warning to the Mexican family and a conference with the manager on her patio.

They took the manager's name and her report.

"I seen what I seen," she told them.

"Yes, ma'am, we believe you," one polite policeman said.

"He must have seen you call us, got rid of the stuff before we showed up."

"Next time call before he knows you spotted him up there."

"You sure better bet I will."

The youth climbed back out after the police had gone. Not onto the sloping roof where he was hidden from inside the house, but onto the back porch roof where he usually only read or watched the sky. He stared down into the parking lot. He lit another cigarette, blew the smoke toward the apartment building.

The manager reappeared instantly in the parking lot, stood and stared up at the young Mexican.

"You better come on down 'n pick all them damned dirty avocadoes, boy. My tenants got a right to park their cars they don't get hit with rotten avocadoes."

The young Mexican didn't answer, only sat silent and smoking the marijuana cigarette on his flat roof outside his window.

```
THE COSSACK WAS PHYSICAL
VIOLENT
WITHOUT MIND OR MANNERS
WHEN A JEW WANTED TO SAY
"A BULL IN A CHINA SHOP"
HE SAID "A COSSACK IN A SUCCAH"
HE INTENDED AN IMAGE
OF ANIMAL VIOLENCE
OF AIMLESS DESTRUCTIVENESS
```

"Trilling, Lionel," Mr. Joachim said. "Introduction to *The Collected Stories of Isaac Babel.* You know the Babel short stories?"

"No."

"A Jew in a Cossack regiment in the Russian Civil War and Polish Campaign after World War One when the whole world tried to destroy the Bolsheviks including this country. We even sent troops to Siberia to fight alongside the Japanese against the Red Army. You didn't know that, did you? It does not suit the image of the nation we want our people to believe at the moment, eh? The reporting and writing of history can be highly selective. What the powers that be want you to know and what they don't. Marshall Budenny's Red Cavalry, that's where the little city Jew rode with the dashing Cossacks. Budenny was still in the Red Army in World War Two. Did you know that? No, you wouldn't have been taught that either. They teach no enemy history here. It was in the campaign against the Poles, who were also fighting to help restore the Whites to power in Russia, that Babel learned it was impossible for Jew and Cossack to understand each other. Not until the

Jew became a Cossack, or the Cossacks turned into Jews. Or until, perhaps someday, the merge of both Jew and Cossack in one human being. Is it possible? Who knows, eh? Babel himself disappeared in one of Stalin's purges. It seems that in the end neither Cossack nor Jew is a match for the cunning Georgian rug dealer, the sharp Yankee peddlar, the eternal opportunist who makes the rules for himself."

Mr. Joachim lay in his living room bed in the warm night, his eyes turned up and watching the play of reflected light on the room ceiling. Moving light from the windows of the cars that passed out in the parking lot. The fluttering shadows from the leaves of the Mexican's avocado tree blowing on a soft night wind in the glare of the parking lot floodlights.

"She does not like the avocado tree, our good manager, and she does not like me. I sleep in the living room, leave the drapes open, hang foolish signs in my windows. It gives the building a bad name. People pass and see me in bed in the living room. My lights are on all day and until God knows when at night. Our manager does not like me sleeping in the living room where strangers or other tenants can see me and come to the notion they can move in here and live like all the other *pachucos* in the neighborhood. Six in a room, it don't matter boys or girls. Mom and Dad and the kids all together just like animals. The landlady insists there must be no more than one to a room, except, of course, in a married bedroom, and certainly no one in the living room. Not on a bed, for God's sake."

Dan sat beside the bed on one of the two straight chairs from the kitchen table where Mr. Joachim ate when he decided to have a meal out of bed. In the moving night shadows on the walls and ceiling he saw the artificial eucalyptus leaves and the koala herself in the holding cage deep inside the zoo building far from the passing people. "What will she do? The manager? Her or Mrs. Stockman?"

Mr. Joachim smiled up at the slow dance of light. "What can they do? I'm an old, dying man. I pay my rent on time. I don't keep women, own a motorcycle, have a pet, let strangers live here, or make too much noise. They can check and see if

the city allows a dying man to live alone in his own apartment, and they probably have."

"They aren't that stupid."

"Stupid, no, but as I said, the manager does not like me one bit. Because I despise her and she knows it. Because I am old and listen to strange music and do not speak as 'real' people do. But, no, there is nothing she can do. I don't need anything, have all I want. I'm beyond anything she can do to me. She can't control me or even reach me, and our Mrs. Anson does not like that at all. It makes her uneasy to know that someone doesn't want what she wants, need what she needs. She has no way to deal with someone who thinks in a way she does not. It makes her nervous, uncertain. When she is nervous and uncertain she becomes afraid, and when she is afraid she hates."

In the zoo all day the koala grew worse. They grasped at straws, tried to think of any way they could help her. They all knew so little about koalas. Few people knew much, not even in Australia. With his best bedside manner, Dan cajoled and coaxed the listless little marsupial for hours each day. He and Carl Warren and some of the other keepers tempted her every day with the tastiest handpicked eucalyptus leaves. It did no good. The tiny creature seemed to fade in front of his eyes.

"How many symphonies did he write? Mahler?"

"Ten finished, one unfinished. Life is never tidy. Ten finished if you count *Das Lied Von der Erde*, and most people do. Eleven symphonies if you count both *Das Lied* and the one he died before he could finish. Someone else finished it, the Tenth, only a few years ago. Alma approved—she was his young widow. She lived over fifty years more, married two other prominent artists, but she remained, always, Alma Mahler. We do not know if Mahler would have approved of this reconstructed Tenth symphony. There's a bass drum in the last movement of this Tenth. Single strokes of fate. Boom! Boom! Boom! He got the drum from hearing a fireman's funeral in New York city back then in perhaps 1908 or 1909, and he used it in the final movement of the symphony he died before he could finish."

Dan saw the landlady's skinny daughter pass through the parking lot in her pickup with the white-painted tires and wheels. "You said eleven if you count both the one he didn't number and the one he didn't finish, not ten. That means someone finished the Eleventh for him, doesn't it?"

The manager's daughter and her green pickup passed, and Dan looked out Mr. Joachim's window at nothing. But not really at nothing. He saw the koala, Ingrid, listless on her branch in the perpetual twilight of the back cage, tried to think of anything he could do. Anything at all.

Mr. Joachim said, "Mahler learned late in life he had a serious heart condition. He became aware of his own death. He had always known death, written about it. He had lost too many brothers and sisters when he was young, had lived with death in his music. But now it was himself and it was real. He would die, and soon. Beethoven, Franz Schubert, Dvorak all had written nine symphonies and died. Bruckner died while he was writing his ninth. So after Mahler finished his Eighth he didn't number the next, gave it only a name: *Das Lied Von Der Erde,* "The Song Of The Earth." When he did not die, but went on and wrote another symphony, it was really his tenth, but he had to number it the Ninth because he hadn't numbered *Das Lied,* and so the last one he did not live to finish could only be numbered ten but it was really the Eleventh."

In the darkness of evening, Dan let his eyes close, saw only the landscape inside. "Who won? I mean, Mahler made it in the end. He finished ten symphonies, if you count the one he didn't number. Only the other side won too. Destiny, fickle fate. He died after number nine, never got to finish number ten."

"What counts?" Mr. Joachim said. "What is, or what appears to be?"

§

The printed sheet announced that South Coast Associates, Property Management, would take charge of the operation of the apartment complex beginning immediately. The management of South Coast Associates urged all tenants to bring any

complaints or needed repairs to its attention, the owner wished to maintain the high standards of the property and insure that all units were in perfect condition for the tenants.

South Coast Associates emphasized in the flyer that its office hours were 9 A.M. to 5 P.M. five days a week. An emergency number was available for the weekend. Tenants should make every effort to bring problems or complaints to South Coast's attention during normal working hours on weekdays, reserving the emergency number for urgent and immediate problems. The owner would pay for all charges and repairs not incurred through the tenants' own actions and normal living. South Coast Associates was glad to be assuming day-to-day operation, would do everything to make tenant satisfaction maximal.

Teams of men appeared almost at once to sweep, prune, water, and generally improve the cosmetic appearance of the buildings and grounds. Small men who smiled but spoke little English. Mexicans and Vietnamese, Guatemalans and Hmongs from Laos. They hosed and swept and hammered fences and trimmed the trees and bushes. They shined and primped and raked and bagged avocado leaves. They did little else. His leak was still leaking, the hot water in the laundry room was still not very hot. He took his rent to the manager.

"Come on in then."

Mrs. Anson sat as usual on the couch with its tufted fringe of red and green to match the flowers and leaves of the couch itself. She watched television in the always half-darkened room, scooped a dip with taco chips, munched.

"I brought the rent."

Displayed on the table in front of her was a large frosted layer cake in the shape of a rabbit. There were the ears frosted in pink, and the heavy body in white with a pink tail, and four pink feet. Three pink feet, actually, the rear two together as the rabbit sat on its haunches. The eyes were blue jelly beans, the whiskers sugar sticks, the pink nose a larger jelly bean. A full sculpture of an Easter rabbit in cake, two-color icing and jelly beans.

107

"You sends it to that management company like the paper you got says. You got the address."

"Leaks too?"

"Plumbers're supposed to be here next week. Then the electricians. 'Preventative maintenance' they calls it, or something like that."

"From now on?"

"Long as they lasts."

"You think they won't do a good job for the landlady?"

"I seen 'em come, I seen 'em go."

She ate a scoop of the bean dip on a taco chip, and watched the television. Impassive.

"That's a nice cake. Did you make it, Mrs. Anson?"

"Every year for Easter."

"Easter's that close? I've been so busy I guess I lost track. They usually do a lot of special events at the zoo for Easter. They tell me everyone brings their children, but the adults have as good a time as the kids. I'll have to get working on the exhibits if Easter's that close."

"Two weeks. Kids like to look at the cake before Easter."

"Your granddaughter?"

"My son got a couple. They comes over weekends to see it."

"Doesn't it get stale?"

"I keeps it covered. Anyway, it's a kind of fruit cake stays fresh a long time. Used to bake wedding cakes when I was younger 'n worked in a bakery. It's that kind of cake. Ain't hardly no one knows how to make that kind of cake no more."

"You could probably sell them. If you made others."

"I done that. I don't no more."

"That's too bad. I'll send my rent to South Coast then."

"You do that."

The koala became more stable in her twilight world, still silent on the single branch, but moving sometimes to pick at a tender leaf. Easter approached and they geared up for the Sunday influx of fathers who never went anywhere with their children, mothers who attended church with the kids twice a year and came to the zoo afterward, guilty older brothers and sisters

who thought of their religion and siblings this one day a year, and divorced parents of both sexes who remembered how special the day was to many kids so brought them to the zoo either alone or in the uneasy company of their ex-spouses.

At the apartment complex the manager's bunny cake was the talk of the neighborhood. She put it out on a folding table in her patio under a special large plastic dome and let everyone in the complex bring their children to see it once a day in the late afternoon. Her daughter's friends trooped through to admire it, and stayed for smaller cakes and coffee in the living room of flowered slip covers and oak veneer, everything dusted and plumped up for the occasion. Her son brought his children. They sat in their Sunday best in front of the cake in the living room. The youngest asked for a piece of cake.

"Not until Easter, Shawna," her mother said. "My goodness, you know that." A thin woman, she sat silent most of the time with her head always half turned toward her husband.

"We don't touch that cake before Easter, Shawna," the manager said. "You just learn to wait, young lady."

The older of the manager's son's children, a thin, pale boy, sat in silence the whole afternoon and watched the cake.

Some of the tenants asked if they could bring their children's school friends to see the cake, and eventually even the neighborhood kids came through to stare at the wonderful cake under its plastic dome. The school friends talked and giggled, but the neighborhood children stared in a kind of mesmerized silence as they filed slowly past the table and the plastic dome and the magnificent cake under it.

Easter was still two days away when the rabbit cake was destroyed. It was on display as usual in the patio behind the manager's apartment. The manager's daughter painted her tires in the parking lot. The manager sat inside the apartment on the couch to watch the daughter's crawling child. Two neighborhood boys who had been there before came in and stared at the cake. The taller and older, a thin, Indian-looking Chicano boy with dark-shadowed eyes who had been told four times before that the cake would be cut on Easter Day for the family and

the apartment tenants' children if there was any left after the family, reached out and pushed the whole thing to the ground —plastic dome, china plate, table and all. The cake smashed and the thin Chicano boy jumped on it. His friend jumped on it. All the neighborhood kids, and even some from the apartment complex, started jumping on it until the outraged daughter swept through and hurled them away. The manager came out screaming, the kids scattered, and the Chicano boy got away in the melee.

"That fucking little *pachuco* bastard!" the manager raged as she looked at the ruins of her magnificent cake. "I'll hang the little shit by his fucking balls!"

She called the police. This wasn't a matter of Mexicans and marijuana, so the police went around the neighborhood somewhat reluctantly. No one would give the boy away, and neither the manager nor her daughter knew his name or were absolutely sure what he had looked like. The police had to suggest that next year she keep the cake indoors instead of showing it to kids who weren't going to get to eat it.

She refused to bake another cake for this Easter, so none of her grandchildren would have rabbit cake this year.

"You go thank your little brown brothers," the manager told them.

THE GREAT MAJORITY OF A PEOPLE
DOES NOT CONSIST OF PROFESSORS
OR DIPLOMATS
THE SMALL AMOUNT OF KNOWLEDGE
IT POSSESSES
CHANNELS ITS REACTIONS
INTO THE REALM OF EMOTION
THE MASSES ARE RECEPTIVE ONLY
TO FORCEFUL EXPRESSIONS
POINTING TO EITHER
THE POSITIVE OR THE NEGATIVE
NEVER TO A HALF-WAY STATION
BETWEEN THE TWO
BUT THIS
EMOTION-DIRECTED ATTITUDE
ALSO MAKES FOR
SOME EXTRAORDINARY STABILITY
FAITH IS HARDER TO SHAKE
THAN KNOWLEDGE
LOVE
IS LESS SUBJECT TO CHANGE
THAN RESPECT
HATRED
IS MORE LASTING THAN DISLIKE

Mr. Joachim sat propped up in the bed with his eyes closed, the TV on and soundless as always, the heavy throb of the stereo playing in the dusk of another evening. Where Dan sat in the single armchair across the room, he knew he was learning to hear again. That was one of the goals he had hoped to reach. To strip away the thick layers of years, hear and see what was there.

"It's Mahler," he said. "But a new one for me, right?"

Mr. Joachim nodded. "The Sixth, the Tragic. Alma always said it was the most personal of all his symphonies. She is in it, the Alma theme. But it is also his most objective symphony. The most formal, most classically constructed. Perhaps he knew that what was closest to him, all that was best in the civilized man of the enlightenment, would soon be destroyed at the hands of those confined so long down below, and he wanted to cling to the illusion a little longer. You see, he knew the great tragedy of the twentieth century would be the rule of the barbarians, of the small and fearful, the ignorant and narrow."

Eyes closed, Mr. Joachim's voice had a way of blending into the mood and rhythm of the music. Relentless, like a grinding march of the implacable. Tragic. In the armchair, Dan listened to the harsh voice of Mahler, the great sweep of agony and despair for the whole world. Somehow, Mr. Joachim's voice always took on the same rhythms and tones of the music he played. At least the tones and rhythms of all the Mahler. Dan didn't know if the old man's voice did the same with all music.

"You didn't put a name on your sign again," Dan said.

"Do you like it? 'Faith is harder to shake than knowledge.' You might add that faith is also more certain than knowledge."

"Like isn't the word I would have used about those words. Probably true is more to the point. Who said them?"

"The supreme barbarian himself," Mr. Joachim said. "Adolph Hitler. *Mein Kampf*, pages 200 and 371."

"I never knew he was that intelligent."

"Intelligent, no. Smart, yes." The old man opened his eyes and looked toward the back of the sign hanging in his window. He couldn't read Hitler's words through the heavy cardboard, but he knew them. "In the final analysis, all he did was see, learn, understand and apply the principles of modern mass market advertising and public relations to politics and social order. And he did it long before Madison Avenue realized the potential and began making our presidents. That was it. All he needed to convince a few hundred million people to go march-

ing out to slaughter fifty million of each other and destroy a quarter of the world."

"Isn't that a little hard on Madison Avenue?" Dan said. "Advertising and public relations didn't create the Nazis."

On the bed in the twilight room, Mr. Joachim shrugged. "Neither hard nor not hard. A fact not a judgment. We are responsible for what we unleash on our world, or what other worlds there may be, whether we intended any particular use or not. Advertising simply discovered a key twentieth-century truth about human beings. A truth many kings and politicians already knew, and Hitler only used with perhaps more devastating effect than even he suspected he could. A truth our politicians have learned quite well by now. A truth the Axel Springers and Reverend Jerry Falwells and their like have applied to religion and morality, public mass communications and entertainment."

§

Dan's soon-to-be-ex-wife brought Moonface to him.

Margaret sat on the edge of her chair in the apartment, wrapped in the same anger, fury, and incredulity she'd had on the day he told her why he was leaving what he no longer wanted. She looked slowly around the almost bare living room with its sparse furniture where he now lived instead of in the fine house they had shared for so many years with an expression of disbelief. A disbelief she had brought in with her, her head turned to look behind the same as Carl Warren. But Margaret looked back not at the giant signs in Mr. Joachim's window, but at the parking lot, the ramshackle house of the Mexican family on the other side of the fence, the entire alien neighborhood.

"You like this?"

"Like what, Peg?"

"This!" She gestured angrily at the spartan apartment, the blacktop parking lot, the small houses of the poor neighborhood outside. "This . . . place. Everything here."

"I like working at the zoo. The apartment is something I

don't have to waste time thinking about. The natives are mostly friendly and some are even interesting. What did you come about, Peg? I can't have a cat here."

Margaret sat with the cat on her lap, and tried to smile pleasantly, to make her face at least neutral. "I'm leaving town, Dan. Probably permanently. I'll keep the house, of course, rent it out. It's a good investment. But I've got a very good offer to go to New York and work for my old boss at the management consultants, and I've decided to go. I don't have much to stay here for, do I? With Katherine in college, and you. . . ." The edge of her anger crept back into her voice, but she fought to hold it off at least until she got what she needed. "It means a lot of money, opportunities to work with old friends and meet new people. I'll probably go back to school for my doctorate, the company has suggested they would pay for it if I went at night. It would make me more valuable to them, and, incidentally, to anyone else in case I want to look around and see where I can perhaps do better, eh?"

"It certainly would increase your market value."

He heard the ironic edge in his own voice. Smiled to soften it. That didn't help.

"If you're going to work, you want to get the most you can. The most of everything. That's the world we live in, Dan. At least, the world I do. And I'm going to need a new life now too, aren't I? Not that I wanted. . . ." She shook her head, angry with herself for showing anger. "I can't leave the old cat at the house when I rent it, and I can't take her to New York. It's not practical and Moonie would hate it. You always liked Moonie, she'd be much happier here with someone she knows. Where she can have the same veterinarian now that you're out of the small animal practice. All that."

"They don't allow pets here, Peg."

"I can't take her with me."

"What about one of the neighbors at the old house?"

"They all have cats coming out of their ears, or they hate cats, or they're allergic. Look, Dan, if I can, when I'm settled I'll send for her. I'll send the money to ship her, and you can

send her on to New York. Meanwhile, you know she uses a lit-
ter box, and will be perfectly content indoors. You don't ever
have to let her out if you don't want to. When Katherine grad-
uates she'll probably want her."

There was really nothing Dan could do but take the cat.
Margaret could not, would not, take the cat to New York. She,
Margaret, could abandon the cat, would abandon the cat. She
would, in the end, have it destroyed if that was all she could
do. It was his daughter's cat, a student couldn't take care of a
pet, or even have one. Moonface was happy with the litter box,
had never had much interest in going out. He took the cat, put
the litter box in the downstairs half bathroom, and didn't let
her go out where she could be seen by the manager or the
owner on one of her periodic inspection visits.

Moonie explored the new apartment corner to corner on
both floors. When she had investigated the entire new world
she was going to live in, she began to sit in the window facing
the parking lot where the solemn young husband with the
brown Ford Escort wagon parked every evening. Dan tried to
keep her out of the window, but it wasn't possible. He drew
the drapes whenever he went out, but Moonface soon learned
to crawl under and jump up on the sill. In the window in front
of the drawn drapes she was even more visible. Dan gave up
and left the drapes open.

"You can't have no cat," the manager said.

"She's just an old cat," Dan said. "She never goes out."

"That don't matter. Landlady says no cats."

"My ex-wife had to leave her here with me until she gets
settled in New York and sends for her."

"You can board her out."

"She hates other cats."

The manager shrugged. "I don't know about all that.
Owner says you can keep a pet one month, then you got to get
rid of it or move out."

§

Mr. Joachim's favorite Mahler was the tragic Sixth symphony with its bleak, lost themes and its hammer blows, its harsh grinding rhythms, its despairing finale. Dan liked the Sixth, but he decided he liked *Das Lied Von Der Erde* more.

"The Song of the Earth," Mr. Joachim said. He was in the bed. Dan had never seen Mr. Joachim anywhere else. Always in the bed, his eyes fixed toward the ceiling above the bed. "The new age of the barbarians, the twentieth century. He saw that, Mahler. He saw that our twentieth century with all its horrors would be inevitable. The old aristocrats and warrior classes would have to live and rule in a new way in a new world, and would have to let the barbarians from below come inside at last. The newer civil servants and genteel middle class couldn't keep them out any longer. All the *outs:* the serfs, the peasants, the faceless, the mute and invisible. The raped and pillaged and whipped and starved and mutilated of so many centuries. The barbarian masses unseen below and untouched by the civilization of the upper classes. The nameless and faceless of thousands of years. Freed but not made free. Emancipated but not educated. Given the vote but not the culture. Allowed into the civilized world, but not civilized. The twentieth century belongs to them, and either they will become civilized and go forward into some new world we can't know yet, or they will destroy us."

Das Lied Von Der Erde. The song of the earth as Mahler saw it was a long drinking song and a farewell. Dan could hear it, the farewell, in every Mahler he listened to in Mr. Joachim's apartment or heard through the wall between the apartments. Goodbye to the universe. Long and sad and futile and endless, regret fading slowly away in *Das Lied Von Der Erde* on the soft voice of the alto: *Der Abschied.* In so many ways, Mahler was nothing more than one long farewell. A farewell that ushered in the new century and, eventually, Auschwitz.

"Which," Dan said. "Go forward or destroy?"

The television flickered in the sunlight. The stereo faded with a final echo of the farewell.

"A matter of time and chance," Mr. Joachim said from his perpetual bed in the living room. "If one single man can be

Mahler, then all men can be Mahler. Neither Jew nor Cossack. A new form of mankind. Perhaps then we will have a chance, we human beings, *homo sapiens sapiens,* the glory and horror of the universe. But in the end, even that will probably not be important. We will not last that long anyway, not on a cosmic scale. Oblivion for the earth. Tomorrow. The earth and us. It doesn't really matter to any single one of us though. When I cease the planet ceases with me."

"Maybe we'll find some other planets out there in the stars. Get in our space ships and find another galaxy and another planet and go on."

Mr. Joachim smiled. "The western mind and need. But I think we will all cease with our sun. A minor accident in an unimportant corner of infnity."

"Doesn't that make each of us nothing?"

"Or everything."

IN THE FACES
OF THE STORM TROOPERS
GUARDING THE HALL
YOU SAW A VAIN EFFORT
TO FOLLOW THE DETAILS
OF WHAT THE SPEAKER
WAS SAYING
BUT THEIR FACES
DID NOT RELAX
WHAT THEY HEARD IN HIS WORDS
WAS SOMETHING THAT
WITHOUT HAVING CREATED
ANY INTELLECTUAL CONCEPTS
WILL EMERGE
IN SOME STREET BATTLE
WHEN THEY WILL DEFEND
THEIR SWASTIKA

—DEUTSCHES VOLKSTUM, DEC. 1927

The young woman in the apartment on the other side of Dan wore high heels and a series of sheath dresses to ride to work on her moped. Tall, as awkward on the high heels as a young gazelle, she was no more than a girl. Mrs. Anson and her red-headed daughter came out to stare at the girl riding past on the slow-moving moped, proudly erect and wearing a helmet with her sheath dress and high heels. The girl didn't notice as she rode out of the parking lot, clearly unaware of how she looked or of anyone watching her.

She had moved in soon after Dan, and immediately needed to borrow a hammer from him. She knocked on his door, took

his hammer, but was so excited by her new apartment she remained to talk for an hour. Her name was Janice, she was nineteen and on her own away from home for the first time. She played lead guitar in an all-girl rock band trying to get started in the music world. She had a mother, father and two brothers in the Valley. She loved them, but had nothing in common with them. She had no time for boyfriends until the band hit the charts. She loved animals, and it was wonderful he was a veterinarian at the zoo.

"If I wasn't a musician I'd want to do something like that. Work with animals, you know?"

A softball second baseman in high school, Janice had worn high heels and a tight dress only when her parents had made her until she got her first job. A job necessary to support her new freedom. She wobbled on the high heels, and was always pulling down the sheath dress when she walked. An athletic stride, her walk, and neither the shoes nor the dress worked with the walk. They were even worse for riding a moped. But she couldn't afford a car, hated buses, and the moped was her only way of getting around on her own. It was a symbol of her independence from her family out in the Valley, and she didn't have any other clothes she could wear for work in the office of an automobile agency. It was either the sheath dresses and highheels, or ragged and cut-off jeans, gaudy vests she wore when the band played gigs, sweats, softball uniforms, baggy shorts, work boots, and T-shirts.

"I guess I kind of miss the softball sometimes. Three years varsity. Good field, not so good hit. We had a nice team, even if some of the girls drank too much beer and the coach got mad all the time. They all had ghetto blasters too. They played terrible music. After I started the band, got really interested in music, I didn't fit in with the team as much. But music was more important. I told the coach. He didn't like it."

In constant motion, she reminded Dan of the humming-birds that hovered over the hibiscus and trumpet vine, swooped up and down the air along the back fence between the apartment complex and the house of the Mexicans with the

avocado tree, fed equally on the flowers in the apartment gardens and the blooms in the Mexican family's yard.

The girl's friends visited constantly with their records and guitars, beer and shrieks.

"This mankiller is Marge, she plays bass in the band, and that's Amy on drums. She's the screwed up silent one unless she drinks too much. All drummers are screwed up and drink too much. Sandy is keyboard and sings. We all sing. I'm lead guitar and *numero uno* songwriter."

The small, undulant Marge came on so strong it was almost funny at Dan's age. She often arrived in a Mercedes driven by her father and departed in a Jaguar driven by her mother. The manager stared at Marge's cars as much as at Janice on her moped in her high heels. Amy the drummer was heavy and full-breasted, dark-haired, and far too voluptuous for her age and clothes. Amy sometimes sat out on the girl's patio all evening in ragged khaki shorts sucking a beer while the others jabbered. Sandy was shy and beautiful, soft and silent, except when the girls were alone inside the apartment and then her voice would rise laughing above all the others except Janice herself. They were all loud and eager, and every morning Janice ran out of her apartment at the last minute to hop onto the moped, pedal madly until it started, and vanish out of the parking lot in a left turn still pedalling to get up speed.

"It's one bad, bitchin' apartment, you know?" She told Dan, and grinned like the child she had been only a year or two ago. She was both proud and defiant in her living room with its chrome and canvas couch from the Salvation Army, stereo on the floor, TV set, unfinished coffee table, and single standing lamp. "God I was lucky to get it, and so *cheap*. You wouldn't believe how hard it is to get an apartment in this town if you're a kid. Nobody under eighty allowed, and no kids or pets. Christ, where the hell are the kids and pets supposed to go?"

"Isn't it still too expensive for you?"

"I guess, but it's the cheapest we found and my own place, you know? I mean it's mine all alone. This is it. A job, my own

place, the band and some real gigs soon." The moped, the band, and the apartment were her symbols of herself, of her identity.

She was going to be a professional musician, they all were, although Dan noticed that the music and the dedication seemed to have a little less intensity and urgency to the drummer and the singer, than to the bassist and Janice herself. But while they practiced, played small clubs where the only pay was the chance to get up and play for an audience other than your mother, father and friends, and waited for the real gigs, Janice worked at the automobile agency to pay for the apartment and a studio where the band could practice.

"It's over a metal plating shop down near the tracks. Our studio is, I mean. No one lets you practice in apartments or houses, especially at night, and what with school and working when else can we ever practice, you know? Besides, who has a room or even a house big enough to hold all our stuff? I mean, a whole drum set, all the wires and amplifiers and electronics for my guitar and Marge's bass and the keyboard and all. Anyway, down there nobody hassles us about the noise, or the pot, or anything else."

"Why do you not just live there, young lady? Save so much money?" Mr. Joachim asked.

"They won't let us. Zoning and all. No cooking allowed, bad environment, whatever." She shrugged. "Besides, we share the place with a guys band so's we can afford it. If anyone lived there, no one'd get to practice. I mean, a guy did crash once. Backup drummer of the guys band never even paid his share of the guys half of the rent. Moved in his sleeping bag, hot plate, drum set, and dirty jockey shorts. No place, no cash. It was the studio or the street, okay? He swears to us he'll come up with some rent soon as he gets on his feet. So we say okay, one week. Three weeks later he's moved in two beds, a color TV, and a girlfriend. He's still free-loading, and we can't get him out with dynamite. So much garbage no one can even practice. He won't leave or pay a nickel. He says it's his place and he's staying. If we call the cops he'll say we let him live there and we'll all lose

the studio. We don't want to call the cops anyway, maybe get him in real trouble. I mean, we're sorry for the poor guy, we all know what it's like with no money and no real place to go, but we got to get our studio back. The guys band wants him out too, but they don't want a brawl. No one wants to give the guy bad trouble. I mean, it was a real problem, you know?"

"It was a problem, yes," Mr. Joachim agreed. "And what did you do to remove this person without causing him trouble?"

Janice laughed. "We took turns watching the place until he had to sneak out to get his unemployment check. Marge went up and made like she was an old girl of his. The ladyfriend got so mad she followed Marge back out screaming. Amy and Sandy ran in and tossed all his stuff out except the TV and the drums. I had a locksmith all ready, and he changed the lock. When the creep got back he couldn't get in, we said we'd kick in his drumheads if he tried anything, and we'd keep the TV until he paid some back rent."

"Did he pay?" Dan smiled.

"Hell, no. After a while his girlfriend came around again and told us he had to have his drums to play a gig or starve, so we let her take them. Couple of months later we heard he left town, left the girlfriend high and dry. Sweet guy. I still have the TV set. He probably stole it anyway."

Not all of them had jobs or their own place. Marge the bassist went to college, lived at home, paid her share out of an allowance and money her parents would have had to pay if she went away to college instead of staying home. Amy the drummer lived with her brother, worked in his beauty salon. She hated it, but he paid pretty good and he didn't charge her any rent so she had more money in her pocket. Sandy had a boyfriend she'd lived with for over three years, and worked as a waitress at a club where the tips were good. Sandy and Amy were both older, they had been on their own before, and their own place wasn't as important to them. But for Janice the apartment was, finally, the essence of her freedom to be herself, a place where she could write her own songs.

"You have to write your own songs for your own band," she explained. "You can get away with covers when you're just kids, but if you want anyone to take you seriously you have to play all your own songs."

"Covers are other people's songs?"

"Top forty stuff, what the name bands record. We still do some covers, but I'm working hard. Down here I'll get a hell of a lot more written than back home, so I had to get a real job. The agency's kind of fun anyway. They're pretty nice people down there. Crazy, but real. Not like my parents' dead friends, or the Valley kids, or the high school teachers. Some teachers were all right, but most you never could reach, you know? At the agency they're real. I mean, they worry about money, and their girlfriends, and what they're going to do Saturday night. They tell jokes and laugh a lot. They get drunk, and they have these monster hangovers at work, and they wish they had more money, and they go out on the town dancing, and they listen to records."

In addition to the canvas couch, her expensive stereo and four-track recorder, the studio-squatter's TV, the unfinished coffee table, and the standing lamp in the smaller one-bedroom apartment, she had a bunk bed, a desk and canvas chair from her room back in the Valley, a table and two kitchen chairs from garage sales, and her records. The records were in stacks of cardboard boxes all along the bare walls. Rock bands of every possible type, but mostly one particular kind Dan found better than the others, a rock music he'd never heard. There was something different about the records, almost like advanced classical music.

"Minimalist," Mr. Joachim told him. "Steve Reich, Terry Riley, Philip Glass, John Adams, Daniel Lenz. Electronics and amplification. Mahler and Schoenberg, they did not need electronics, but it has its advantages, its voice. Some things only it can do."

Day in and day out Janice listened intently and intensely to her favorites. She played them sometimes for Dan and watched his face as intently as she listened to her music.

"That's Sting, don't you just grab him? You don't know Sting? The Police? Listen—!" She threw back her head and sang, "*Hey, Roxaaaaaaaaanne . . . Rrrrrrrrrrrrooooooxxxxxxx-aaaannnnnnn! Hey, Rooooooooxxxxxxxxxxxxxxxxxxaaaaaaaaaaaa-aaaaaaaaaaaaaaaaaannnnnnnnnnnnnnnnnnnnnnn!* And listen to Andy. Andy Summers. On the guitar. You're saying you don't know Andy Summers? Sting? Adrian Belew? What do you *listen* to?"

"Right now, Mahler," Dan told her. "Gustav Mahler. He was an Austrian composer around—"

"I know who Mahler was. What do you think? Hey, I listened to Mahler when I was ten."

"I never had time for music," Dan said. "No time for much at all. Mr. Joachim is teaching me Mahler and Bruckner and a lot of other composers. He says some of what you play reminds him of Steve Reich or Philip Glass."

"Oh, sure, the minimalists. They're smooth. My dad likes them. Adams and Terry Riley too. He listens to them all the time. He likes Mahler and Bruckner too. I give him a record every Christmas. God, do they ever cost. They make classical records better. So what did you have time for made it so you didn't have time for music?"

"Study, work, money, women, family. The whole thing. Always busy making money, building my career, buying the big house in the Valley. What I was supposed to do. Success, responsibility. Son, student, husband, father, and veterinarian. Building my place in the community for the good of all."

She giggled. "The women, that's okay. I'm gonna have kids someday too. But the rest of that, wow, what a heavy trip."

"Too heavy, too narrow, too rigid, and too much," Dan said, smiled. "I decided it wasn't what I wanted. My wife didn't agree with that decision. We wanted different things, different paths to the pursuit of happiness."

"Hey, I'm sorry. That's heavy too, but it sure does sound like my family. You can't breathe, you know? Hey, listen to this. This is *King Crimson*. Don't you just hang on that guitar? That's Fripp. You ever see him? Oh, man, he's like this lit-

tle sort of accountant. Suit, tie, white shirt, regular shoes, feet on the floor. He just sits there and picks at that guitar and everyone else is going crazy. He pushes his glasses back on his nose and picks away. He's adorable. And can he ever play . . . That's Adrian Belew . . . This is *Pink Floyd*. You know *The Dark Side of the Moon*'s been on the charts over ten years! The longest record ever, and *Pink Floyd* isn't that big and famous, you know? It just grabs people . . . the words say so much."

They listened to records all day and night, Janice and her friends. The stereo never stopped whether they were there in a crowd or Janice was alone. They seemed to communicate with and through the records the way poets once did through slim volumes. The records, the music, the voices and the words were their newspapers, television, books, gossip, family conversation, and love affairs all rolled into one.

> . . . *rush*
> *Into the lobby of life of hurry up and wait*
> *Hurry up and wait for the odd-shaped keys*
> *Which lead to new soap and envelopes* . . .

The records were events in themselves. Mental and physical happenings no different from a war or a murder or an election or a love. Reality. The records were the same as reality. They were reality. The singers and the songs and the faces on the dust jackets were as real or more real than the people they passed on the streets. More real than their teachers and fellow students. More real than their families. The way magazines and books are to so many older people. The way movies and television are to most people at the end of the twentieth century.

> . . . *So now sometimes I pray*
> *Please take the space between us*
> *And fill it up some way*
> *Take the space between us and fill it up some way.*

When Dan talked with Janice and her friends, listened to her records through the wall the way he listened to Mr. Joachim's music through his other wall, he knew that the records were as real to them as books, TV, movies, newspapers, the actual people she met. Yet he sensed that it was different, too. Records were their only reality, the only way they talked to each other, made contact, understood. The records, the music, the faces on the jacket covers, were their world. The actual world they had inherited was something they could not consider real. What their parents and other older people called the real world had no relation to them. As the world of his pet poodles and big house in the Valley had come to have no relation to him. Only the records were real, the music and the words and the faces of their peers. Only the animals in the zoo.

". . . You got to listen to all the words, Dan, okay? They got it right. Doesn't that make you want to cry? Down at work I play my blaster all the time and all the guys listen, you know?"

> *The child is grown*
> *The dream is gone*
> *And I have become*
> *Comfortably numb.*

Janice and her friends didn't really work at their jobs the way other people did, with a sense of career, of the future, of security. They carried their youth with them, accepted no discipline or responsibility, refused to take on the weight of the society they had been given and were expected to serve and help move forward, gave no thought to the judgment of other people. Dan realized that Janice and the others saw the adult life they had been shown as false in the sense of its demands. A response to what they saw as the essential uselessness of what adults did, a dreary wasteland of making more money to put in the bank and hoard so you had it when you got old and no longer had any reason to spend it except to stay alive. A radical response to extreme prosperity, as youth had once responded

radically to extreme poverty. Responses that come when poverty proves that the mature values of adults don't do what they promised, or when prosperity proves that even when it works what adults do isn't worth doing.

Another suburban morning
Grandmother screaming at the wall.
Daddy only stares into the distance
There's only so much more that he can take
Many miles away something crawls from the slime at the
Bottom of a dark Scottish lake . . .

They sat on the floor, ate yogurt from the containers Janice always had in the refrigerator, sent out for pizza, drank their beer or soda indiscriminately, smoked their pot. Snorted cocaine when someone could afford it. Some of them sometimes did more than cocaine. No one questioned. Vague and loose, without direction, and if they had ambitions they talked about them in the same way as the undirected dreams of their music. Plans and programs brought only the nervous adult world they had been born into and feared. There was no pressure, no forced pattern, no necessary logic. No one had to talk, no one had to respond. Whatever came to mind, and the only connection was the records.

I am a face
In the painting on the wall
I pose and shudder
And watch from the foot of the bed
Sometimes I think I can
Feel everything . . .

§

Janice turned up with the RESIST AUTHORITY bumper sticker on one side of her moped about the same time the old couple in the ancient Cadillac began to drive through the parking lot

to scavenge for aluminum cans in the two large trash and garbage containers. She already had MAKE LOVE NOT WAR on the other side of the moped.

The manager, on her morning task of sweeping and raking and picking up, stopped to eye both the old couple at the containers and the new RESIST AUTHORITY sticker on Janice's moped. She, the manager, looked at each in turn, as if fixing each in her mind. Janice noticed the manager and her unsmiling face.

"Something wrong, Mrs. Anson?" Janice asked, an edge to her voice.

"If there is, there ain't gonna be for long," the manager said. "While you's resistin' authority 'n all that, you just be sure you don't have none o' those friends o' yours stayin' in your apartment. You got a one bedroom apartment, that means one person sleeps in it. Now you been told that, but I been hearin' maybe some o' those friends you always got hangin' around they don't leave sometimes 'til mighty early in the mornin'. And I got complaints 'bout that there guitar o' yours. No playin' after ten, you understand that?"

The manager waited, but Janice only nodded slowly without saying anything, and continued to stand and look at the manager. Mrs. Anson pointed to the other sticker on the moped.

"You try making love to them there Russians or them Arabs you gonna come away cleaned out and naked. They wants to take it all, everything we got. You better listen to what the President tells you. He tells us all straight, young lady. War and sneak attacks, that's all some kinds of people understands."

"Really?" Janice said. "What kinds of people would those be?"

"You know who I mean. Them stickers don't help no one 'cept the enemy."

"They help me, Mrs. Anson. They help me a whole lot. They make me feel good. They surely do."

The next evening Janice appeared with ONE NUCLEAR

BOMB CAN RUIN YOUR WHOLE DAY stenciled in red on the front and back of her T-shirt. The manager stood behind her own patio fence with her hands on her hips and watched Janice parade past between her apartment and the laundry room. Janice went back and forth many times, far more than usual. Neither the manager nor her daughter appeared outside in their patio again that evening.

§

The old couple always arrived at the apartment complex early in the morning with the back seat of their ragged and dented old Cadillac piled with sleeping bags. The old man drove the car slowly through the parking lot, while the old woman walked to the large trash containers and poked through them with a long stick that had a double hook on the end designed specifically to fit into the opening in an aluminum beverage can.

Dan watched them from his window and wondered where they came from, how they had gotten into a situation that made them pick cans from the trash to make money? They looked very much like his own parents as he remembered them when he graduated from college, when he first went to work at the riding stable and zoo back home. Even the way they had looked when he made the move his father had approved so much, left the stable and married and took up the private practice on high-strung poodles, overweight cats, and an occasional pet rat and hamster. He tried to picture his mother and father in the battered Cadillac, digging through the trash. It took his mind momentarily off the dying koala. But he couldn't imagine them so smiling and real, so resilient, anymore than he could imagine them ever approving his return to the zoo. It wasn't the divorce they hated, it was the loss of the house in the Valley, the loss of income. Dan began to separate his own beer and soda cans from the rest of his trash. He put them out on top of the garbage just before the old couple arrived each morning to make it easier for them.

It didn't take long for the manager to appear and nail NO TRESPASSING signs on the fence at the entrance to the lot, on all the telephone poles, and above the two large trash containers at each end. NO TRESPASSING, VIOLATORS WILL BE PROSECUTED: THE MANAGEMENT. When the old man started to drive through the next morning, he stopped. He stared at the signs on the fence and poles. The old woman got out to walk to the trash with her special stick, and stood uncertain when she saw the sign above the first container. The old man got out too, and they stood together in the morning sun talking to each other and looking at the signs.

Janice came out of her apartment carrying a large paper shopping bag. She took the hooked stick from the old woman, walked with it in her hand to the first container, and poked carefully through the trash and garbage. She pulled out all the aluminum cans she could find. Then she walked to the other container at the far end of the parking lot and poked through it. She put all the cans she found into her shopping bag, went back to the Cadillac, dumped the cans into the car's trunk, and stood talking to the old couple until she had to leave for work and they had to drive to their next stop.

After that, Janice waited for the old couple each morning at the entrance to the parking lot. The old man parked and sat in the Cadillac outside the entrance, while Janice and the old woman worked together to pick the aluminum cans from the garbage containers. With two of them digging, they worked much faster and found more cans. Janice always talked with the old couple for a time before she had to get on her moped and go to work and they drove on to their next trash containers.

"They lost their house a couple of years ago. They couldn't pay the property taxes so had to sell the house," she told Dan. "They couldn't afford to buy another house, the old man got sick, and they had to live on the money they made from selling their house. It ran out, they've been trying to do more than just stay alive ever since."

"Don't they have any family to help them?"

She shrugged. "Their kids are in the East, don't have any money to give them. They've got Social Security, but everyone knows that's not enough. They worked all their lives, and we give them just enough to stay alive but not enough to have any real reason to stay alive." Janice shook her head in anger. "I had a teacher in high school who said that was the Puritan ethic. People are supposed to take care of themselves, everyone separate from everyone else, and if they can't take care of themselves they have to suffer because it's their own fault, a sin against God. He didn't teach for long, Mr. Mullins. Last I heard he had a job operating a fishing boat up in Avila Bay, said he liked it a lot better out in the air and sun."

> IT MAY HAPPEN
> THAT A NATION
> STOPS DISTINGUISHING
> BETWEEN RIGHT AND WRONG
> AND THAT IT WILL CONSIDER
> EVERY ONE OF ITS BATTLES
> TO BE "RIGHT"
> BUT THIS NATION ALREADY STANDS
> ON A STEEP INCLINE
> AND THE LAW OF ITS FALL
> IS ALREADY WRITTEN
>
> —ERNST WIECHERT, APRIL 1935

One morning before Janice came out to meet the old couple, the manager's skinny daughter's pickup truck wouldn't start. This was a fairly common occurrence. It was an old truck, and the daughter drove it long and hard and never took it into a garage. She and her friends repaired and serviced it themselves, and when it wouldn't start this morning she made her usual call for help.

Two other pickups soon arrived to the rescue, roaring into the parking lot to skid to a stop around the daughter's ailing vehicle. Two muscular young men in baseball jackets, jeans, and heavy boots, jumped out and greeted the daughter with derisive laughs and slaps on her arms and narrow rump. Two young women in identical baseball jackets and tight jeans, long hair, lipstick, and high heels followed them out of the pickups.

The manager's daughter disappeared into her apartment and reemerged with two sixpacks of Pepsi. She handed a can each to the women who leaned on her low patio fence, tossed

two to the men who had shed their jackets to reveal T-shirts with sleeves cut off at the shoulder, and popped a can herself. The men prepared to plunge into her pickup's engine. The daughter stood with the other two women, hips cocked and moving, and taunted the men to hurry up.

"What's taking so long, for Chrissake. Hey, any two-bit wetback beaner snuck into the country yesterday could fix a truck faster'n you two turds."

The other two young women joined in with peals of mocking laughter. The men responded with threats from inside the raised hood, and graphic details of what they would do to the women later if they didn't stop their yapping. The redheaded daughter went to the truck to challenge the men to touch her, and to help them out with the engine. They all had a good laugh, and the young women switched to talking about what they and the men had done at another friend's party last night. They were loud, and soon drew the manager to her screen door.

"Hold it down out there, Cassie. You knows better'n to make all that racket so early."

The daughter had been at the party last night too, and began to split her time between talking to the other young women about it, and putting her head inside the truck hood to discuss the problem with the two men. It was while she was half hidden inside the truck hood that the old couple drove up outside the parking lot and parked on the street at the entrance.

Janice, dressed as usual for work in her heels and sheath dress, came out of her apartment carrying her shopping bag as she had all week, and joined the old woman. With the hooked stick, they began to poke through the first trash container. The manager's daughter, who had raised her head from the engine to call out something obscene to the other two young women, saw the girl and the old woman.

"Shit now, if it ain't our little bleeding heart and her old garbage divers."

The daughter's two young women friends turned to look. The young men raised from the engine to stare at the girl and

the old woman. The manager's daughter said something in a low voice, and they all laughed. The other two women left the patio fence to join the daughter and the two men at the daughter's pickup, to whisper to each other and laugh even more.

The old woman at the trash container hesitated, glanced toward the five of them whispering and laughing around the truck. But Janice went on searching through the trash for the aluminum cans and dropping them into the shopping bag as if she hadn't even noticed the manager's daughter and her four friends. The daughter laughed louder, urged her friends on with nudges. Janice still paid no attention. The manager's daughter raised her voice.

"Some people they likes to roll in garbage, I guess."

The four friends snickered. Janice and the old woman finished with the first container.

"She lives here, then she goes 'n helps them two old robbers steal our stuff."

The old woman became frightened, didn't want to walk past the daughter and her friends to the second container. Her eyes pleaded with Janice, said they could make do with only the one container today, it was all right. Janice said nothing, walked straight toward the second container at the far end of the parking lot. The old woman trotted uneasily beside her.

"Hey," the manager's daughter said as the old woman and the girl passed the five who now leaned against the disabled pickup, "here's some more garbage you can pick up."

She tossed her almost empty Pepsi can at Janice's feet. Some of the cola splashed on Janice's skirt and panty hose. Janice bent, picked the can up, and dropped it into her shopping bag.

"Beautiful girls," Janice said, "have big hearts."

She continued on past the group around the pickup toward the second container. The manager's daughter's four friends all laughed aloud. The manager's daughter half laughed and half scowled. She knew the girl was being sarcastic, that was okay, that kind of shit didn't bother the manager's daughter. But she vaguely sensed she had been insulted too, that her friends were

134

in part laughing at her, but she wasn't certain of exactly what the insult had been. She pushed the arms of the two men to reassert her claim on them.

"Hey. She wants Pepsi cans. So we gives her Pepsi cans!"

The daughter grabbed an empty can one of the men had already tossed into the back of the truck, and threw it again at Janice's feet. The other four all threw their cans in front of Janice and the old woman. Janice picked them all up, dropped them into her bag, and continued on to the second trash container without so much as a glance at them.

The manager's daughter glared after her. Her two woman friends made remarks about the way Janice still wobbled on the high heels she wore for work. The two men returned inside the engine of the pickup. When Janice and the old woman came back past them toward the ancient Cadillac outside the entrance, the manager's daughter whispered to the two young women, and the three of them ran to one of the other pickups.

Outside the entrance to the parking lot, Janice put the bag of cans on the street while the old man opened the trunk of the Caddy and the old woman watched. At the wheel of the second pickup, gunning the motor, the manager's daughter bore down on the entrance with her two girl friends. Oblivious to any traffic that might be coming along the street outside, the daughter tore through, barely missing the old man, the bag of cans Janice grabbed out of the way at the last moment, and Janice herself.

On two wheels, with a screech of rubber, the pickup made the turn out in the street, and drove off with the manager's daughter and her two girlfriends looking back and laughing wildly. But as they had made the violent turn to drive along the street, they had lost the unopened second six-pack of Pepsi the daughter had brought out for her friends. It sailed from the pickup and landed on the street near the old Cadillac. Janice picked it up.

Up the block the manager's daughter jolted to a halt, and began to back up. She leaned out her side window and yelled back at Janice.

"That's my six-pack you got, you hear? You better just hand it over right now."

The pickup continued to back slowly toward the parking lot entrance. Janice carried the six-pack inside the fence, waited until the manager's daughter could see, then dropped it into the first trash container. She returned to the old couple, smiled, patted them on the shoulders, and sent them on their way in the dilapidated Cadillac. Then she walked to her apartment and went back inside.

The manager's daughter parked again outside her patio fence, and got out of the borrowed pickup in a rage. She told one of the two men to get the six-pack of Pepsi from the trash. Neither of them would. The daughter was angrily picking the six-pack from the garbage herself when Janice came by on the moped on her way to work. Janice waved, peddled the moped up to speed, and sailed away out of sight along the street.

§

Janice continued to help gather the discarded cans from the trash using the old woman's long stick with the hook.

"They sleep in the car," she told Dan. "They eat only a couple of meals a day, and what they make on the cans is just the difference. They can have a little fun. Go to a movie. Buy some ice cream. They do pretty good with the cans. Sometimes they pick up enough newspapers to make a few bucks, and they're always finding old stuff they can sell to thrift shops for a little extra money. When they do that, they can even afford some good meat for dinner."

Then Mrs. Anson herself came to knock on Janice's door one day after she got back from work. The manager paraded, firm and purposeful, straight up to Janice's apartment.

"I been talkin' to the owner. She don't like people coming in here and takin' stuff out of the garbage. She don't like people just walking in from outside 'lessen they come to see some tenant."

"They need the money," Janice said. "They're old, and poor, and they don't have enough to eat."

"We got welfare for that."

"Don't you believe in personal initiative, Mrs. Anson? Individual enterprise? Work not handouts?"

"Stealin' ain't work."

"From the garbage?"

"It don't make no difference. Them cans don't belong to them old crooks, 'n the parkin' lot don't neither. They're trespassing. You trespass on property ain't yours and take what belongs to the owner or the tenants, that's stealin'."

"Those cans go to the dump, the county separates them out. The tenants and the owner pay to have them hauled away, and then don't get any of the money. Those old people need the pennies more than the county does."

"It don't make no difference what happens to them cans. The trash belongs to the apartment, 'n the owner got a right to do whatever she damn all wants with it. Them old tramps don't live here."

"I do," Janice said.

And she went right on poking through the garbage every morning before she went to work. She continued to fill a bag with the cans, to take it out to the old couple who waited out on the street in their battered Cadillac.

The manager continued to watch over her patio fence.

The manager's daughter continued to glare furiously every time she saw Janice.

§

While Dan fought in the twilight world of the back cages at the zoo to stem the koala's decline, the girl suddenly lost her job.

"They said I play my music too loud, make too many mistakes. Bullshit! The boss always told me my blaster was okay. 'It's fine, Janice, go ahead and play it, the staff likes the music.' And I'm the only damn one there knows how to add two numbers and write a decent sentence."

"What do you think happened?" Dan asked.

"I know what happened. I got friendly with a black guy the service manager doesn't like and wanted to fire, that's what

happened. I told the black guy, Johnny Clay, so he could get to the big boss first and head off the service manager. After that, the service manager couldn't fire Johnny without a really good reason, and he didn't have any real reason. That made the service manager so mad he got *me* fired instead."

"Can't this Johnny Clay tell the boss the truth?"

"He's got a wife and three kids. He can't get in the middle of a personal fight like that. He might really get fired if the service manager made it a real fight." Janice shrugged, and smiled. "What the hell, it was a lousy job anyway."

She started looking for a new job at once. On Dan's personal recommendation she went to the zoo for an interview, but the jobs they had were too technical or didn't pay enough money. She decided to try to land a job with some connection to music even if it would take longer. Her rent was due a few weeks after she lost the job. She didn't have enough money in the bank to pay the rent and live until she got a music job, so she wrote to the owner for an extension.

Two days later the manager put an eviction notice in her mailbox.

It wasn't for nonpayment of rent. Instead, it was for having nonpaying guests living in her apartment. For making too much noise with her parties and loud music. For sleeping more than one to a room. For constantly breaking apartment rules and annoying her fellow tenants. In view of this bad record as a tenant, the notice said, the extension could not be granted, and she was ordered to leave immediately since her rent had not been paid when due.

Janice called the manager who told her she was just doing what the owner had told her to do.

The owner refused to talk to Janice at first. When the owner finally did agree to talk, she said only that she'd heard too many bad things about Janice and her friends from the manager and it would be better if she left quietly.

A lawyer friend Dan sent Janice to told her there was little she could do, and she could do nothing at all without a lawyer. She couldn't afford a lawyer without a paycheck. She would

not go to her family. She finally had the promise of a job, but it would be some weeks before she started, and the manager was adamant. Janice had become too much of a problem.

Janice cried. "It's my first apartment. Mine! I mean, it's the whole thing, you know? I just can't go back living with my folks. They don't understand. I love them, but they don't know. They just don't know. They don't feel what I feel, you know, Dan? They smother me, hold me down. It's like a locked room with no windows or doors or even air. I can't go back. I can't!"

"For a month," Dan told her. "Maybe two. To get on your feet, keep your studio. Time to pay off the agency for the new job, and put enough in the bank for first and last. Then you can get another apartment. That's not so bad."

She cried and cried.

"I can't! I can't!"

"You have to put away money. What's a month or so?"

The tears streamed down her despairing face.

"I like it here. It's the best place I ever lived. My own place."

"You'll get another apartment."

She shook her head back and forth, back and forth, as if she wanted to shake her head off.

"It won't be the same. It just won't be the same."

It wouldn't be. Dan knew that.

She went on crying in the patio behind her apartment. Dan tried to calm her. He told her it wasn't so bad, she would recover from the small setback. But he remembered how bad it was when you were nineteen and lost something you wanted so much, so desperately and excessively, with the hope and hunger of youth.

It was then they heard the laughter. Dan heard it over Janice's tears almost as soon as she did. From the patio of the manager's apartment. They were both there, the manager and her scrawny daughter, laughing at the crying girl. It made her cry more, and the more she cried the more they laughed. Until Janice ran into the building, into the apartment that wasn't hers anymore.

Then the manager and her daughter went back inside too, wiping the tears from their eyes and still giggling to each other.

A few days later Janice left.

She didn't want her parents to know she had lost the apartment, so she moved in with one of her girlfriends without telling them. It would only be until she could get enough money for a new apartment, but in the meantime there wasn't room in the friend's apartment for any of her things. She lent her records to Amy the drummer, her stereo to Marge the bass player, and a lot of the furniture she had bought for her first apartment to all her friends, a piece here and a piece there, until she got another place. All she could take with her were her guitars—the electric and the old acoustic she'd had since she was thirteen.

The night before she left she had too many beers and went to the manager's apartment and told her how much she appreciated all her help, how very kind Mrs. Anson was.

The manager and the daughter laughed in her face.

Next morning Janice was out early with her moped, her coat and gloves and helmet on. Before she got on the moped to ride away for the last time, she took her large paper bag and went to the garbage and collected all the aluminum cans she could find and took them out to the street where the old couple would pass. She gave the cans to the old woman, who shook her hand, and kissed her, and said how nice she was.

Then Janice went back into the parking lot and ripped down all the NO TRESPASSING signs. She threw them into the garbage containers before she got on her moped and rode out of the parking lot, peddling like mad to get up speed and signalling for a wide turn into the street.

> **THERE IS NO CURE FOR BIRTH**
> **OR DEATH**
> **SAVE TO ENJOY THE INTERVAL**
>
> —George Santayana

After Janice left the apartment complex, the old couple stopped coming to search through the trash for aluminum cans. For a few days Dan waited for them out by the large trash container with his own cans in a paper bag. On the third day, when they again passed the entrance to the parking lot without turning in or even stopping, he dropped the cans into the trash under the new metal NO TRESPASSING signs the manager had bought and put up in a cold rage, and went off to the zoo.

As Janice had made him think sometimes of himself as a boy, the old couple had made him think of his parents. In both cases because the old couple and his parents, himself as a boy and the young girl, were really so little alike. He could not begin to imagine his most proper father and properly supportive mother even owning anything as extravagant and vulgar as a Cadillac, much less living in a rundown old one, and there was no way his father could ever have allowed himself to be so profligate, impractical and careless as to fall into the criminal situation of the old couple.

"There's only one cause of people being poor, Daniel, no matter what they try to tell you in that college, and that's spending more than you earn. Not a damn thing else, and that applies to boys, men, cities, states and countries. You remember that, and you'll never have any trouble."

He couldn't imagine his mother ever touching aluminum cans that had once been in the garbage. "We wash our hands

and faces before we eat because we're people and not animals. Civilized people, from a civilized country. Is that clear?"

They would have been furious at the lack of foresight shown by the old couple, and would have hated the loud and careless girl guitarist as much as they had liked, admired, and welcomed his soon-to-be-ex wife. Hated the girl who had been nothing at all like him as a boy, but had felt so many of the same things, as he now guessed most children felt. Maybe even his own girl. The hunger to be. To be and to become. The ache to exist in your own eyes. A person, important to yourself and perhaps then to everyone else.

That wasn't something his parents had encouraged, any more than they had encouraged his friendships with those boys who were probably very nice in their way, Daniel, but came, really, from a different world, and weren't, really, the kind of boys one brought home. The boys he went to school with, played baseball with, kicked the can with on long winter nights.

They lived then, he and his parents, on a short road with a gate where it joined the main road. Most of the kids on the short road went to one of the private schools in town, but his father considered a public education important so that he, Dan, would know the world of the *others*. After a time all his friends came from the other side of the gate. After school, they met on the open field next to the school for baseball in the summer and football in the winter. They met after dark the two nights a week his parents allowed him to go out to play after dinner. They played hide-and-seek or kick-the-can, and sometimes in winter built a fire on the open field next to the school and sat around telling stories. A lot of the other boys' parents had come from foreign countries after the war, and he loved to listen to their stories.

But the best of times were the late-night games of kick-the-can. There were six boys and three girls and him. He was the only one from the road behind the gate. Four of the boys were just like him, even though their parents had come from Poland and Italy and Hungary, but the other two were different and

came from somewhere in Asia. Two of the girls were athletes in school, played on the basketball team. The other girl came from Mexico but spoke pretty good English.

Even now Dan could feel the thrill of those kick-the-can games, the three girls as active and daring as the boys. Someone always freed the prisoners, sent the can sailing high into the darkness with a powerful kick while they all scattered into the shadows and the can-keeper raced to retrieve the can and get back to the circle in time to shout the names of those he could still see. Until someone finally missed the kick, or only managed a feeble distance, and the can-keeper had them all. Then a new can-keeper shut his eyes and began his count as they vanished once more all across the field and the school yard.

Dan was one of the first who had to go home on those winter nights, the first to be called away from the fire if the game had ended early and they were keeping warm and telling stories. If, as happened much too often, he had lost track of the time and not arrived home by eight o'clock, the call would come from his mother's car. One especially cold night, when they had played long and hard but still wanted a fire, they were around the flames far later than usual, until, as it turned out, past nine.

His mother, on her way to the car to retrieve him, was delayed by a neighbor who had lost her cat and needed advice and comfort, so was herself late. At the fire the others left or were called, and he began to realize something was wrong. When there were only three of them left, the boy whose parents had come from Poland and the Mexican girl and himself, he had begun to hope. They were always the last two at the fire, the Polish boy and the Mexican girl, the last to leave the baseball games in summer. The boy, Kasimierz known as Casey, was the boldest, the one Dan admired above the rest. The girl, Lena Olivares, was the most independent.

Dan began to hope that this time he would sit and watch them go home, be the last at the fire. Call after them, "Hey, it's just getting good, you guys. Don't chicken out on me." Then, alone at the fire he would sit and stare out at the night as they

slowly faded into the darkness. He would look up at the stars, listen to the cars pass on the roads, feel alone and strong, the last to have to go home.

But it wasn't to be. Not that night, not ever. Really responsible people like his parents, aware of what was good and bad, were neither overindulgent nor carelessly lax with children. His mother's car appeared, the call came, and he once more had to leave his friends at the fire. It had been so close, so near to happening, he had to say it to his parents this time, face them at home inside the front door in the anger and near-tears of twelve.

"I'm not a baby! Casey can stay out past nine-thirty!"

"What other people choose to do is not our concern, Daniel," his mother told him.

"Eight o'clock is quite late enough on a school day," his father said. "Now get ready for bed."

"What's so special about eight? I don't go to bed before ten! I sit up there doing nothing. I don't get to sleep before eleven."

"Eight o'clock is when a twelve-year-old boy should be home," his father said.

"You need quiet time before bed, Daniel. To rest and calm down and think of what you have to do tomorrow," his mother said.

"Casey and Lena don't have to rest! They're the smartest and best out there, and they never go home before nine!"

"The Wiltkowski boy is overindulged," his mother said, "and that Lena has no parents at all as far as anyone can see."

"Don't compare us to those people," his father said. "Responsible parents know what's good and what's bad, you understand me?"

"At least Casey and Lena don't live in a jail!"

His father slapped him then. Being twelve, he started to cry. And, being twelve and a big boy, tried not to cry, wiped furiously at his tears, looked at the floor and raged at himself for crying and despaired at the same time.

"I just want to be the last one out there like Casey, that's all."

"That's no excuse for insulting your mother and me," his father said. "Go on up to your room."

"Now that you've made your father hit you," his mother said, "perhaps you see why we don't want those children here."

On the stairs he shrugged. "They wouldn't come anyway. None of them ever invite me home. I guess their folks don't think I'm good enough for them."

"Get up to your room!" his father shouted. "Now!"

Dan never did get to be last at the fire, was never to bring Casey or Lena or Tran Duc or Attila home. He got the best grades in the public school, went on to college, and, in consultation with his father, decided to continue in medicine. A good boy. His parents' good boy. In the image they carried as an icon inside. And then not a good boy.

"Animal medicine," he said. "It's what I've always wanted to do since my first summer at the zoo."

His father decided he only had himself to blame. For letting Dan's mother talk him into agreeing to allow Dan to do summer work at the zoo instead of in his father's office where his father could have seen to it the boy learned to want the right things. The zoo and that damned horseback riding the mother said would be good for the boy when everyone knew that only girls rode horses anymore. Boys rode bikes and motorbikes and tinkered with cars and dreamed of owning a Mercedes or Jaguar or some other great automobile.

"Veterinarians do seem to make a good living," his mother pointed out. "The prices I've heard they charge to take care of people's pets. You can't even get prescription pet medicine except from a veterinarian."

"Large animals," Dan had said. "Horses and maybe cows. Zoo animals."

His parents barely spoke to him for years after college. All the money they had wasted on him. A veterinarian in a riding stable! They never visited him when he lived over the stables and treated the horses and was on call at the zoo and spent his free time working with the zoo vets. Not even later when the only job he could get that paid enough was with a private vet-

erinarian hospital where they treated small animals as well as large. Not until he married his wife and went into a private suburban practice on his own and made real money.

Margaret had gotten along well with his parents, and after he married her they smiled on him again. Dan had often wondered, the last five or ten years, what it was that had attracted him to his wife, aside from the obvious physical part. All he could come up with was that they had the same background. She was white, Anglo-Saxon, middle-class, educated. The daughter of Northern European parents who believed essentially what his parents believed. She cooked the same foods his mother did, had the same cultural memories.

They had the same frame of reference.

He began to realize that more marriages happened from that common frame of reference than from love, compatibility, or common interests. Sex and the same tribal history. That was why he had married whom he had married. But passion will founder without compatibility, and without that passion the same myths are not enough. In the end she had a lot more compatibility and common interest with his parents than with him. They wanted all the same things, assumed all the same things, believed all the same things, had all the same values. Values he suddenly knew a year ago he had never really had.

His parents hated the divorce. They refused once more to speak to him, and raged, too, in the same voice and nearly the same words as his wife.

"What is it with you, Dan? We really don't know. What have you wanted all these years you don't have? You have a nice house, a good car, the best clothes, everything you could want. The best vacations, first class everywhere. You seemed to want that all these years. What are you going to tell your daughter? How will she understand a father who runs away from everything important?"

"I want to do what I always wanted to do."

"The whole world wants your life. Don't you tell us you don't want your life. You have everything anyone could want and more."

"I don't have what I want."

They were like the pet owners he had known over the last fifteen years. Their life was their sense of power, their dominance, ownership, tyranny. Their son and what he wanted wasn't real, only they were real. Them and what they wanted.

The difference now was that he didn't care. He thought it was funny. He thought it was ridiculous and told them so. His father looked at him exactly as he had that night when the twelve-year-old Dan had told them he had always wanted to be the last at the fire. The way his father had looked just before he slapped him. His father didn't slap him this time. His father was uncertain this time, afraid to slap him, because in his father's world the stronger would slap back and his father was too old to be slapped now. So his father and mother simply refused to talk to him, and sat back there in the East wrapped in their anger.

Their son had wounded them as deeply as it was possible to wound a parent. He had gone on a different path, denied their truth. That could not be forgiven, and they would go to their graves without ever knowing why life had not been better for them. Why it had all not been happier. Why they had never really enjoyed much of anything except the daily self-assurance that they had lived the way you were supposed to live.

§

At the zoo Dan sent away to Australia for different, even more special eucalyptus leaves. He asked the Australians for advice. The Australians had none to give.

"Shipping koalas so far, it's reasonable to expect one or two might suffer the stress-type syndrome they do seem to suffer," Melbourne zoo veterinarian Ray Butler said over the long-distance telephone. "And once it gets to a certain point it seems to be irreversible, the poor animal's had it."

Dan sat night after night with the little marsupial where it clung listlessly to its branch in the darkened cage and stared at him or at nothing. Or perhaps it stared at some inner memory of a now distant Australia where its ancestors had lived out their lives for more than a hundred million years. Dan sat with

her during the day and on into the night when Carl Warren had other duties to do. Sat with her until he had to go home and get some sleep. He went home to sleep, but was far too tense to sleep, shimmering inside, restless after the silent hours in the dark room behind the koala cage.

"You gone and done it again, Calder."

The manager's furious voice on the telephone.

"You got some kind o' special reason you got to park in apartment E's space?"

"Sorry. Just tired, I guess."

"Tired don't mean nothing. Tired don't do no one no good. Everybody they's tired sometime. Jerry he got a right he should park in his own space."

"I said I was sorry, Mrs. Anson. It isn't some devious plan of mine to annoy apartment E. I'll try not to do it again."

"Try don't mean nothing neither. Smartass big words don't mean nothin'. You park in your own space. If someone else's in your space, you come to me and you tell me."

Then he was angry. "I've got better things to do with my time than to have stupid fights over parking spaces! I'll park outside my patio fence. Will that suit you and mister Jerry of apartment E, Mrs. Anson?"

"So long's you don't block no one's space, and don't block the people drives in and out."

The koala finally stopped eating entirely. Nothing Dan could think of would make her eat there in the twilight world of the back cage behind the koala display cage. She hung alone and motionless. A small, silent, slow-eyed figure that clung to her branch as if she were still in the vast and empty Australian outback. Dan now spent all his evenings with her, rarely got away before eight. He stopped for something quick to eat, and fell into bed by ten. Many nights he forgot to put his forbidden cat, Moonface, into her room so she wouldn't sit in the window downstairs where she could be seen and reported to the vigilant manager. He even forgot to take his mail from the mailbox.

"You better start lookin' at your mail, Calder," the manager said when she brought his rent check back to him. "From

now on you goes back to payin' your rent to me. We put a notice in your mailbox. Problems and complaints too. I'll write 'em in the book again. Right now you got to write me a new check. This one it ain't no good bein' it's made out to them South Coast people."

"The management company's gone?"

"Told you they wouldn't be around that long, didn't I?" She was pleased with herself, smiled the wolfish smile that didn't reach her eyes or the rest of her long face but only the thin, triumphant mouth. "Mrs. Stockman, she just gets this idea time to time she shouldn't oughta have to do none of the work herself. She always comes back around to me. When the others they don't do what she wants, when they tries to tell her how she got to run her places."

Dan sat alone in the dim back room at the zoo with its heavy odor of eucalyptus leaves and decay and talked softly to the little marsupial. She had been born in that far off empty Australian outback where her marsupial ancestors had lived changeless lives in the hot and dusty dream time for more than a hundred million years. The child of an ancient and timeless wilderness, she had been brought into alien Melbourne only a month before being sent to America and the zoo. What could she make of it all? The faces, the harsh voices, the glaring lights, the endless noise. A small, slow, harmless creature of the moonlit nights of the changeless outback.

A month from the hundred million years of dust and sun, the koala was put into a box, trucked to a jet, flown for twenty hours across the Pacific, trucked to the zoo, then put on exhibition under bright lights before a sea of passing faces. Faces and the endless pounding of voices. Light. Light. Light. Sounds. Sounds. Sounds. Faces. The endless faces that stared in at her. The highway a few hundred feet away. The railroad. The faces. Staring. And the light. Always the glaring light.

The koala was his Valley pets and their owners carried to the ultimate conclusion. The animal as toy, as stuffed doll, as game, as slave, taken to the final extreme. The total existence of one living creature for the use of another.

§

Herman Binder had the suppurating lump on his shoulder for two weeks. Binder lay awake at night and worried through the days. He walked his large, lumbering walk through the parking lot without talking to anyone. He seemed to even forget his silent woman.

"Carrie she says you're an animal doc." Binder stopped Dan on the way to the laundry room. "I figured you got to know a real good doc where I could go."

Dan smiled. "You have a sick horse, Herman?"

"Can't have no horse around here."

"A joke."

Binder chewed his heavy lower lip and waited.

"Sorry. What kind of doctor?"

"Cancer," Binder said.

The large man's blue eyes were empty and almost colorless as he looked at Dan. A blank stare. Seeing death but refusing to know what he saw. Already dead.

"Can I take a look at what you're worried about?"

Binder shook his head. "I show it to a cancer doctor. He got to know."

"Where is it?"

Binder shifted on his heavy legs, shrugged.

"Internal or external?"

Binder blinked.

"Is it something you feel inside, or can you see a lump?"

"I can see."

Dan nodded. "Doctor Matteus Talbot is a general cancer surgeon. He's about the best. Number 2380 Ventura, near Valley General Hospital."

§

At the zoo, Dan was finally forced to hook an intravenous tube to Ingrid and drip fluids and vitamins into her tiny body. He slipped another tube into her mouth and went on feeding her a carefully ground mixture of the choicest eucalyptus leaves.

He was still at the zoo that day, trying to think of some way to make Ingrid eat, when Herman Binder returned from the doctor and found the cat named Bill lying dead near one of the large trash containers.

Scrawny and ragged, gray and stiff. As rigid and hard as a stuffed toy from a second-hand thrift shop. Without a sign of how he had died. Or why. Herman Binder stared down at the corpse with its skeletal body and dirty gray and brown hair matted in three directions as if the cheap stuffed toy had gotten wet and fallen into the mud. Binder kneeled beside the dead cat and searched for any sign of how it had died. He turned the corpse over. He looked in its rictus mouth. He could find nothing to tell him why Bill was dead.

At the zoo Binder placed the box with the dead cat inside on Dan's desk.

"I want to know how it died."

"From the look of him, Herman, I'd say there was a good chance of malnutrition."

"No. He always looked like that. I'd been feeding him regular."

"Maybe just old age, Herman."

"Then you find out."

"I'll have to charge you if you want an autopsy. I'm sorry."

"I got money."

"It won't help, Herman. He's dead, there's nothing you can do. Save your money."

"I can find out why. He was my friend. I got to know why, you know?"

Dan did the autopsy. Herman Binder sat in his office, silent and erect in a straight wooden chair like a father awaiting word of his soldier son lost in some great battle. Like a man waiting for his own condemnation.

"He was run over, Herman. It doesn't show, but every internal organ is in the wrong place, everything pushed up into his lungs. I'd say a truck got him. He was just too sick and weak to get out of the way."

"No," Binder said, looked down at the emaciated form of

the dead cat in the cardboard box, "he could move fast. He was a smart cat. Too smart. He just didn't care. I figure he never did care much, you know?"

Binder dug Bill's grave among the geraniums in the flower bed along the rear fence between the apartment building and the house of the Mexican family with the avocado tree. It was hot, and Binder sweated. The adobe soil was hard. The sweat ran off Binder in rivers. He wiped it from his eyes and went on digging. He dug harder and deeper, wanting to sweat. Dug without speaking to anyone. His woman came through the passageway from the street in front and watched him for a time. Binder said nothing, and she went back through the passage to Binder's apartment.

Binder dug until he was drenched, his thick, wiry black hair as matted as the rigid body of the dead cat. Until he was over four feet down in the geranium flower bed. Then he dropped the shovel, bent deep into the hole, placed the body of the cat at the bottom and began to fill in the grave. He shoveled slowly, one shovelful at a time, paused after each to look down into the small grave. It took him most of the afternoon to fill the grave all the way, and then return the shovel to the tool shed at the far end of the parking lot. The sun was already low when he sat again beside the grave of the stray cat.

Binder found a large stone. He wrote BILL and the date on the stone with a black marking pen. Then he thought for a time, and wrote his best guess at the date of the cat's birth. That seemed important to Binder. He set the stone into the dirt of the grave in the garden. He sat on the ground and looked at the stone and the grave. In the sun, his back against the Mexicans' fence, he looked at the grave and the stone marked with the cat's name and the date of birth and death. For the rest of the late afternoon he sat against the fence near the grave, his face up to the sun and his eyes closed. His head with its sweat-matted hair against the fence, and his face turned up immobile as the sun went down the sky behind the Mexican family's avocado tree.

The manager found him there when she came out for her

evening round of the grounds. She asked him what the hell he was doing sitting in the dirt of the flower beds? Had he gone crazy? Who the hell had told him he could dig goddamn holes in the owner's flower beds?

"You goin' crazy, Herman?"

Binder told her about Bill and the autopsy.

"Prob'ly got run over by my daughter's truck. That dirty old cat was always sleepin' right under the wheels. I done told you to get rid of that old cat before we all got some disease. Good riddance, I say."

"He was just a nothin' cat," Binder said. "A poor dirty old cat didn't have no home. He didn't hurt nobody. Just a nothin' cat wanted nothin' and got nothin'."

"He had every disease there is, Herman. You should of let me send him off to the animal control people. You're as bad as that big-shot girl was gonna love everyone, Herman. Goddamn bleedin' heart shit."

"All he wanted was to live, eat good, sleep somewhere nice, maybe even have a good time sometimes." Binder shook his head. "He never got nothin'. He was just zero, a plain nothin' cat. Only he had a right to live too."

"What the hell use was he, Herman? You ain't no use, you ain't got rights. Cats ain't got no rights anyhow," the manager said. "You better get out of that flower bed, Herman, and don't go burying no more cats. You ain't supposed to dig in the gardens or nowhere else 'round the apartment. The owner sees you, I got to give you trouble."

"He got a right to get buried, Carrie," Binder said, but he got up and stepped out of the garden.

He didn't go back into his apartment. He sat on the black-top of the parking lot and went on looking at the stone he had set on the grave. Binder was still sitting there in the dusk when Dan got home. On the blacktop next to the flower bed looking up at where the sun had gone down behind the avocado tree. Looking at the stone with the name and date on it, a question mark after the date of birth to show it was only Binder's guess.

"I been sitting here, looking at that stone 'n thinking some-

thing was alive is under there and ain't ever gonna live again. Not ever, you know?"

"How about you, Herman?"

"People, they should look where they drives, you know?"

"What did Doctor Talbot say?"

Binder got up, brushed at his pants where the dirt of the flower bed had caked. "It's a cyst got infected. He can cut it out if I want, but I can leave it alone too."

"Sebaceous cyst?"

"I guess. Something like that. It ain't serious, the doc says."

The big man looked once more at the stone in the flower bed, then nodded to Dan and walked almost wearily across the parking lot and through the central passageway toward his apartment at the front of the building.

§

When the consulting veterinarian from San Diego finally got up to leave Dan's apartment it was late, and Dan found the light brown Ford Escort wagon parked again directly behind the San Diego vet's car the way it had been when the zoo director came over for some beers. Bumper almost touching bumper.

The San Diego vet, summoned by the zoo director to see if he could think of anything to help the koala, had also parked in the space of the young couple in apartment E when he came to talk to Dan. Dan was too distracted about the koala to notice.

The San Diego veterinarian didn't ask to look at the koala herself. The vet listened to the whole history of Ingrid, shook his head, and said there was nothing anyone could do when a koala finally stopped eating. Neither of them said anything more about Ingrid while they worked the San Diego vet's car out from where it was blocked by the brown Ford wagon. It took him and the San Diego man ten minutes to work the car out.

After the visiting vet had gone, Dan sat for a time in his darkened apartment and stared out at the brown Escort wagon that stood like a rock in the center of the black macadam river

of the parking lot. He drank a beer and stared at the dark and silent car outside. Then he got up and went to apartment E and knocked on the door.

"All you had to do was come to me. Just come and knock on my door and we'd have moved the car," Dan said. "All you ever had to do was knock on my door at any time and I'd have moved any car. People forget. People get busy. People get tired. People have worries. A simple knock on my door—'Hey, Dan, you're in my spot,' and I'd go right out and move the fucking car."

"I don't have to knock on your door," the young husband said. "I don't have to ask you nothing. You got to stay out of my space." The young husband stood large in the open doorway. The young wife watched from the middle of the room behind him. She held a baby. They were a tableau, a painting, floating in Dan's weariness like spirits with haloes of shadows, the *chiaroscuro* of the old masters. He thought of his father, *"Get up to your room! Now!"* Of his mother, *"What other people choose to do is not our concern."* Of his ex-wife, *"What is it with you, Dan? I really don't know."* He thought of the men who hunted down and trapped koalas in the hundred-million-year-old red rocks and dry brush and shifting sands and thick eucalyptus forest of the Australian outback. Of all the mothers and fathers who pointed at the silent koalas and shouted at their staring children to pay attention and learn something.

"We all make some mistakes," Dan said. "We all need a little understanding. We all need a little help. To help each other. Is it so fucking hard to knock on a door? So fucking impossible to tell me a visitor of mine is parked in your goddamn space?"

"You stop using that filthy language in front of my wife, you hear?" The young husband glared stone-eyed. "I don't have to knock on your door. I don't have to talk to you. I don't have to say nothing to you. You just stay the shit out of my space."

Then he slammed the door in Dan's face.

> THE VAST MAJORITY OF MEN
> ARE INCAPABLE
> OF INTELLECTUAL CREATIVITY
> AND A NOT INSIGNIFICANT NUMBER
> ARE UNABLE EVEN TO UNDERSTAND
> OR APPLY
> THE ACCOMPLISHMENTS OF THE ABLEST
> THUS MAN, WHO AS A SPECIES
> HAS HAD REMARKABLE
> INTELLECTUAL SUCCESSES,
> PROBABLY HAS HAD LITTLE MORE
> THAN THE MINIMAL
> INTELLECTUAL ENDOWMENT
> TO ACHIEVE THE CIVILIZATION
> THAT WE KNOW TODAY
>
> —ENCYCLOPEDIA BRITANNICA, 1967 EDITION

The soaring voices of the Mahler Eighth. *Symphony of a Thousand.* The Whitsun Vesper Hymn of the medieval Hrabanus Maurus and Goethe's *Faust.* Latin and German. God and man.

"The Latin Middle-Ages hymn," Mr. Joachim said. "A Jew sets a medieval Christian hymn to music, and gives massive glory to the greatest work of the German language. A Jew writes *The Resurrection Symphony.* Another Jew who wasn't a Jew uses Luther's mighty hymn for his *Reformation Symphony.* Angelic choirs from atheists. Judgment Day analyzed by non-believers. A Bohemian Jew puts a *Judentanz* in the symphonic portrait of a German hero. Did we really come so close? Perhaps we did. It is nice to think so anyway. The end of

the nineteenth century and a true concept of what to be human means. 'Humanity,' with a capital H. Rationality. Universality. Brotherhood. Alas, even for them in that time and place, not sisterhood yet. The voices of the women not really heard. But perhaps that would have come too with the triumph of the vision. A vision of unity. Close, even very close, but not close enough. The twentieth century arrived. Our world. The barbarians. Because they never really heard Mahler, eh? They couldn't understand Mahler. They hated Mahler so didn't hear him, swept him away into the bottomless void of their darkness, their hatred, their barbarian ego."

Mr. Joachim propped up in his living room bed, a pale wax face with black eyes. On the Mexican family's roof across the parking lot, beyond the back fence and the avocado tree, the Mexican youth sat in the sun. In the parking lot itself, Binder and his woman were preparing to go for a drive. Binder wore his best suit, opened the car door, patted her rump. They laughed, Binder and his woman, as they climbed in. Binder sat proud and erect in the driver's seat, the woman solid and secure beside him.

"Mahler said, 'My time will come.'" Mr. Joachim looked from his bed out through the open living room windows to the Mexican youth on the roof. He watched Binder and his lady climb proudly into the car. "The barbarians didn't hear him, the civilized didn't listen to him. Not then. Because they, the civilized, didn't understand what he was telling them. They didn't, couldn't, understand Mahler. How could they? They were the civilized, the visionaries, the believers in the rational future of mankind, the triumph of science and reason. They had no idea what he was telling them in that incomprehensible music of his. Because what he was telling them about was today. About now. About death and darkness and the rise of the barbarians who had been shut down below by the civilized owners of the earth. He lived in the end of the nineteenth century and wrote for the end of the twentieth. It wasn't their music, it was ours. We feel him now. After Auschwitz we know what he was telling us. After Auschwitz and Belsen and

Dresden and the gulag and Cambodia and South Africa and the American Indian and the Brazilian Indian, we can hear what Mahler told us. His time has come, as he said it would. But not *his* time. His music's time. That is what he meant. He did not know when that would be, or what his time would look like, but he knew it would come. The time his music had been written for. Our time. His music belongs to today, but he does not."

In the parking lot, Herman Binder and his silent lady sat in the car while the big man carefully started the engine. Binder, even more erect and proud with his pudgy yet delicate hands on the steering wheel, drove stately off with his woman at his side, smiling and nodding to the manager who watched them go with a derisive wave. Off on an excursion, an adventure.

On the slope of his roof beyond the fence, the Mexican youth smoked his joint in the sun.

The manager laughed at Herman Binder and his solemn lady, stared up at the Mexican youth on his roof, frowned in annoyance toward Mr. Joachim's open windows and the arching Latin choruses of Mahler and the *Symphony of a Thousand*.

"He saw it, Mahler. He sensed the world as it was under the so very thin surface of intellect and reason, under the surface of the civilized few who owned the world so thought it was their world. Under this certain and confident surface as fragile as a mirror he saw the real world. The death and the despair and the darkness inside. He saw the dominance of death. The death that frightens us all and terrifies the barbarians. The constant shadow they can appease only by inflicting pain, spilling blood, killing everyone else so that perhaps they won't have to die. The fear of death and the defiance of death and the acceptance of death but always death. Death and angst. The age of anxiety, the Englishman Auden called it, and that is our age and Mahler's age. The naked fear and terrifying uncertainty and impossible anxiety is what Mahler saw would come and wrote in his music. What he could not see was that in this dark barbarian world of his music he himself would not exist, could not exist."

In the parking lot the manager stood in her favorite pose, hands firm on her bony hips, and stared down at the stone Herman Binder had put on the grave of the dead alley cat. She shook her head with a scowl. The Mexican youth was reading now on his roof in the sun. The manager looked up at the youth again, then turned her head on its rigid neck to survey the whole area of the parking lot and apartment building. Slowly, the way a tank turret traverses to observe enemy terrain. Her eyes fixed again on Mr. Joachim's windows and the great chords of Mahler.

"His time could not come until after Auschwitz, but he could not live after Auschwitz. He saw the darkness, but he did not see how the fearful barbarians would react to the darkness and the terror he showed them. He did not see the closing of the minds. He saw the fear inside, but did not see how we would react to that fear. He revealed to us our inner darkness, and expected that this truth would free us, strengthen us, help us. He did not see the terror of it, the return to the idols and the myths of pre-history, the comfort of the tribe, the safety of the old Gods, the reassurance of all the small Gods. Schoenberg sensed, saw something, and returned to Judaism. But Mahler was dead too soon. He did not see that only a few men could be as he was. Face the fear, embrace the anxiety and the humanity. Most could only react to the fear and the darkness with violence and hate and greed. Rape and steal what they could as the ship sank. Anything to save themselves even for a moment. If they had to corrupt and murder everyone else on earth."

The final chords of the medieval Latin hymn reached out the open window. The manager reappeared from the direction of the tool shed. Behind her, the young husband who owned the brown Ford Escort wagon and its parking space carried two shovels. Together, the young husband and the manager loosened Herman Binder's gravestone memorial to the stray cat and carried it to the trash container. The young man shoveled dirt into the depression, smoothed it over to obliterate any evidence of the grave. The manager dug up and replanted two

geranium plants over the spot. She nodded brusque thanks to the very helpful young husband who left to return the two shovels to the shed. Alone, the manager turned to look once more at Mr. Joachim's window and listen with a puzzled scowl to the flowing German of Goethe's Faust.

"If he had lived longer, Mahler, he would have died in Auschwitz, all bones and fear and filth. A pale grovelling skeleton that ran naked between ranks of black uniforms in a smoking dawn to be shot on the edge of a grave he had dug himself. Mahler and Schoenberg and all the others who could be a Jew and write a medieval Latin Christian hymn in a symphony, write a *Resurrection Symphony.* Who could be a Prussian and embrace Zion and hate war and the aristocracy. A world where it was possible for a Jew to write a *Reformation Symphony.* Flung with the skeletons on the dung heap."

The end of the Eighth Symphony, the one before the one Mahler feared to write because all the other great composers had died during or soon after writing their ninth symphonies and so tried to fool the fates and perhaps he did if you went by actual count and not the numbers. But it is the numbers that are magical to the tribe and so Mahler failed and darkness won. A darkness indifferent to men, and numbers and the counting of symphonies or bodies. Oblivious to superstitions and idols and myths and, in the end, to genocides. Indifferent to the numbers of symphonies or the numbers of bodies burned at Auschwitz. Labels and statistics. Perhaps there never was an Auschwitz or even a Mahler. There are those who stand up in their faith and absolute certainty of myths and idols and sweep Auschwitz away because the six million dead Jews do not belong in their myth. It hurts their myth, their belief, their comforting faith, the fables they tell themselves against the darkness and the terror. If I refuse to believe there was an Auschwitz then there was no Auschwitz. If I say Auschwitz never existed, then it never did. Reality is what I say it is. Neither Auschwitz nor Mahler nor genocide exist as long as I believe they do not. Only the numbers count. Mahler lost.

"Or perhaps," Mr. Joachim said, his dark eyes turned

toward the manager out in the parking lot, "Mahler would have gone to Hollywood with Schoenberg and Stravinsky. To rest under the palms with dark glasses on his narrow nose and write movie music. On a balcony wearing flowered shirts and a straw hat, sandals on his pale feet, Alma cooking a TV dinner in a muu-muu."

§

Dan went into the dim twilight world of the back cages to try to force-feed the koala one more time. And when she looked at him one more time, and turned her head away one more time, he knew it was almost over. Sensed the moment, felt it somewhere inside his own darkness.

The odor of eucalyptus so strong, the light so dim, the silence so endless, he could have been somewhere in the vast Australian outback itself—today or a hundred million years ago. Nothing had changed in the outback, or in the hundred million years. Not for her. Only the unchanging universe where she belonged. And she, too, knew it was over.

She clung to the artificial branch, and looked at him with hundred-million-year-old eyes. Soft eyes that asked a single question. Dying eyes. He held the finely ground eucalyptus leaves out toward her, knowing it was futile. The choicest leaves money could buy or anyone could steal. She didn't seem to know what they were. She didn't seem to smell them. She looked at them but didn't see them. She saw, instead, him. Watched him with fixed, steady eyes. Almost with pity.

He put the bowl of food on the floor that was covered with the rough and fragrant imported eucalyptus bark, switched off the last lights, and closed the door.

When he returned some hours later she was on the floor under the fake branch she had clung to until the end. Her fable. Her truth. He told someone else to call the Natural History Museum. They would take her tiny body and stuff it and put it on display in a glass case decorated to look like her Australian outback eight thousand miles and a hundred million years away.

"It's too bad," Carl Warren said. "They don't bother any-one, koalas, you know? They just try to live out their lives back there in Australia. I mean, I don't know, but sometimes I get this idea they got to know a hell of a lot more than we do, you know, Dan?"

After a time Carl Warren left. The museum people wouldn't arrive for an hour. Perhaps two hours. Dan folded the koala's arms, Ingrid's arms, made her look as comfortable as possible, and sat on the floor of the back cage beside her. Somewhere in the building, in some office full of paperwork, a television set was turned on. He heard the voices, the music. Horse music, the cavalry arriving at a gallop. Indian yells. Cavalry and In-dians galloping across the open prairie. A movie. A western.

He sat in the dim light with the pervasive odor of pungent eucalyptus a hundred million years ago and today. Twilight and death. Australia and the great American West. A sense of loss, of something lost long ago. Strong in him, vivid. The movies. Moving images in a distant dark abyss. As strong as the odor of eucalyptus. The Golden West of his early youth. Movies and the Southwest and a boy in a darkened theater that smelled of adult faces where they, too, watched the Old Southwest and the golden screen. An odor of memory.

The boy and a need. An emptiness. A hunger. The white man who became an Indian. George O'Brien. To be George O'Brien the Indian who, at the end, returned to the white world. In sorrow. O'Brien's sorrow, the Indian's sorrow, and the boy's sorrow. The Indian so magnificent, so proud and clean. Was it fear of growing up? Aware, the boy back then, that to grow up is not all gain. To grow up is to lose, too. To lose the truths of the boy and the white Indian. That the simple life is truer than the corrupted life of the 'civilized man,' the self-constructed life of the adult. The Indian world cleaner to man and to nature, to the sky and the sea.

Only a myth—the clean, simple savage. But the dream of the boy. The myth of the clean and noble. The hunger of the child, for humanity, for nobility, for simplicity, for the truth of his need. And the white Indian returned with sadness to his

mature barbarity. The Fall. Cast from Eden. Aware it was necessary to remain close to the dark earth or he would have to carry his own darkness alone inside. The white Indian returned to the white man. Humanity grew up. Mature and savage. Civilized and barbaric. Darkness inside indifference.

Dan sat there in the dark long after they had come from the museum to take the body and skin it and preserve the skeleton and mount it on another eucalyptus branch under an artificial sun in a painted outback where it would look out with its empty eyes for the benefit of bored school children and indifferent parents. Sat alone, and only after a long time got up to go out to his car in the night and drive home.

§

At the ghostly apartment complex, even Mr. Joachim's windows were dark.

In his own apartment, without turning on the lights, Dan sat with a beer and imagined he heard Mahler through the silent walls. The Third Symphony. *What man tells me. What the mountains tell me. What a koala tells me.* What does a koala tell anyone? The Sixth. Tragic. Mahler in Auschwitz. Inevitable. The fading notes of the Ninth. The drum of the Tenth. Thump. Thump. Thump. Fate knocks. Mahler in a lamp shade.

"Calder, you gone and done it again!"

They stood in the late night outside the windows. Looming and luminous in the clear moonlight. Black halos like cut-out dolls. The manager a pale blue megalithic pillar in a thin bathrobe. The daughter, dyed red hair like blood on her shoulders, a quilted trucker's jacket over her lacy nightgown. The solemn young husband, proud owner of the light brown Ford Escort wagon. The young wife, her arms wrapped tight around her own body in the cool night.

"Get your car out of my space!"

"You got to stop this, Calder," the manager said.

"Get it out!"

Dan stood and walked to the open window in the silent late night. "The koala died. Ingrid. She died tonight at the zoo.

163

I'm sorry. I guess I didn't think much about where I parked, I didn't notice."

"I told you before," the manager, Mrs. Anson said. "All that there don't make no difference."

"Get it out!"

Lights came on in other apartments. Windows opened. Doors and windows and voices and faces that peered white as ghosts in the night. Eager faces searching for the thrill and terror of danger. A few of the braver a step beyond their own doors. Herman Binder in his undershirt from the passageway to the street in front, pants half buttoned, sleep-spiked black hair and confused eyes. Binder in his belly and his slippers.

"Carrie? That you? Everything okay?"

"Go back to bed, Herman," the manager said.

Dan said, "I didn't notice. I'm sorry. She's been sick so long. Six months ago she was in the outback. In Australia. She only came here three months ago. Young and alive. Now she's dead."

"What the fuck's he talking about," the quilted shape of the manager's daughter said. "He's crazy, Carrie, you know?"

"Jerry," the wife said. "Make him stop."

"You got to stay in your own space, Calder. You hear me?" the manager said.

"Who the hell you think you are?" the young husband said. "You got a college diploma you think you're better? You think your shit don't stink? College man! Money bags! You and that old fart foreigner sleeps in the living room! You stay out of my space! I'm as good as you and better. You keep your goddamn car out of my space!"

"He's okay, Carrie, you know?" Herman Binder said. "He don't mean nothing, Jerry. That koala and all. He got a lot on his mind. I seen it when I was up the zoo with Bill. He done a good job on poor old Bill. He don't mean no trouble."

The manager looked at Binder. "The owner she don't allow no diggin' in the garden. Ain't legal to bury no cat inside the city limits."

"Legal?" Binder said.

"We dug up the stone, me 'n Jerry, so's nobody knows a cat

164

got buried there. We done that to help you out, Herman. But if they finds out you got a cat buried, the cops 'n the landlady sure gonna be awful mad."

"Cops?" Binder said.

"Landlady don't allow no live cats in the building, 'n no dead cat in the flower beds. You better be thinkin' about a new place."

Herman Binder turned and walked away.

The manager watched Binder go, satisfaction in her narrow smile, and turned her attention again to Dan. "And you better stop all this goddamn crap, Calder. Jerry, he's right. That's Jerry's space. Nobody 'cept Jerry got no right to it."

The four of them stood framed around the window like a circle of giant ritual stones black in the night, blocking the sky in the dark of the parking lot. The sacred black megaliths of the barbarian tribes deep in the dark forests. Menacing and violent.

"Stay the fuck out of my space, you hear? Stay out!"

"Jerry," the wife said. "You're swearin'."

"Shut up, for Christ sake," the husband said.

"Out o' Jerry's space," the manager said, "or out o' here. Now you got that?"

"You got that?" the young husband said. "*Mister* Calder?"

```
THE GODS OF OUR ANCESTORS
LOOK DIFFERENT
THEY WERE MEN
AND HAD A WEAPON
IN THEIR HAND
SYMBOLIZING
THE ATTITUDE TO LIFE
THAT IS INNATE
TO OUR RACE
—THAT OF ACTION
THAT OF A MAN'S
RESPONSIBILITY
FOR HIMSELF
HOW DIFFERENT
THE PALE CRUCIFIED ONE
```

Dan stood at the night window of Mr. Joachim's living room. There were no signs in the parking lot, only the shadowed flower beds and the thick branches of the dark avocado tree of the Mexicans beyond the fence. The low night music was *Norma*. Mr. Joachim never played opera.

"*Bel canto*, Bellini. The worst kind of opera to a good modern German liberal radical atheist. So therefore it is the best, you see? I like *bel canto*, especially Bellini, and always *Norma*. It is absurd as drama, often banal, and sometimes it is the only music that fits what I feel. No matter how absurd the plot, how banal Bellini's music can be, *Norma* is one of the treasures and truths of life. Wagner called it the greatest opera, he hoped *Tristan* was worthy of it. The treasure of truth. The truth of loss, of what is gone, of what will never be again."

"What's the sign this time?"

In the small hours of the night nothing moved out in the parking lot. The manager was gone, and the ghostly pillow jacket and nightgown of the redheaded daughter. The nervous young wife and her outraged husband. Herman Binder gratefully back in his bed with his woman. All the windows dark except Dan's in the next apartment where he didn't want to sit alone, and in Mr. Joachim's where Dan stood at the window looking out at the young husband's light brown Ford Escort station wagon centered firmly in its space. Except that it wasn't a light brown Ford Escort wagon. It was a new silver-gray Mercury sedan.

"*Das Schwarze Korps*, the journal of the SS," Mr. Joachim said. "The house organ of the baby killers, the trade paper of the mindless believers who would cleanse the Earth and make it pure. The ultimate barbarians: anti-semitic, anti-Communist, anti-Christian, anti-Muslim, anti-atheist, anti-deviant, anti-different, anti-education, anti-imagination, anti-human. Pro only themselves."

In the bed and at the window, Mr. Joachim and Dan listened to the late night. Not motionless at all. A night that moved ponderously, an enormous shape in the dark beyond the apartment and the bed in the living room.

"And that is the mistake so many make," Mr. Joachim said to the night. "That the barbarians are against, that they hate the *others*, but they are not and they do not. *Loyalty is our honor. Gott Mit Uns.* Not that *they*, the others whoever and whatever the others happen to be at the moment, are so bad, but that *we* are so good. Fear comes first. Before hate. Fear and uncertainty. Then certainty and hate. Because we must be special, our gods must be the true gods. If we are not special, then perhaps our gods are not true gods, and that makes us uncertain and afraid. Security is not that 'others' are inferior, but that 'we' are superior."

The new silver-gray Mercury was larger than the Ford in the late moonlight. In the rear window of the new silver-gray Mercury, Dan saw the reflection of his own lighted window next door, and in his reflected window the image of Moonface

by moonlight. The old cat in full view of the world in the lighted window. He had forgotten to lock her in her upstairs room or draw the drapes. A cat in a window, and on the stereo a mournful chorus of Druids.

"Isn't that all the same thing, Mr. Joachim?"

"No. The inferior can improve, become, perhaps, equal. The superior cannot become less." Mr. Joachim stared at a distance beyond the window, seeing again the enormous shape that moved out in the night. "My great uncle Felix was the only one of the older generation on my father's side of the family to survive the Nazis. My grandfather's youngest brother. When he was liberated from whatever camp they had put him in, he stayed in Germany, returned to the old family village. It was in East Germany by then, I saw him only once before he died. I asked him why he chose to live in East Germany. He said that at least they thought they believed in human potential."

Two women sang low on the stereo. A duet. Of sorrow and loss.

"How did he survive? Your great-uncle?"

"He never told me. Chance, perhaps. When I asked him about what had happened to him in the glorious Third Reich, he told me only a story of two men he knew in the years before and after Hitler. One of them, Gotlob Eick, had a boy at the same summer camp my uncle's son went to each summer before the Nazis. Hoffman's Kinderheim. Herr Eick worked in the Potsdam ministry with my great-uncle. For the Kaiser and later for the Weimar Republic. Eick was on a lower level, but he and my uncle had come from the same village, had at least known of each other all their lives.

"Eick's grandfather was a day laborer in the forest of Graf Ulrich Nepomuk von Mannstein. People had been there as long as the forest, working for the Count, owning nothing beyond what they had in their pockets. No more to the Mannsteins than the deer or the foxes. But Eick's grandfather suddenly became the owner of one of the Count's cottages in the village at the edge of the forest. My great-uncle said he did it by burning the Count's hunting lodges, shooting some of the

Count's best dogs. Everyone knew but no one could prove it. It was a time of the emerging middle-class. To assert and protect themselves from the aristocracy, they also championed the lower classes. The *junkers* could no longer ride totally roughshod over everyone. Without proof there was nothing the Count could do, so he bought peace and safety with the deed to his unimportant cottage."

The solemn and mournful chorus of priests blended in the dim apartment with the fading movement of the night over the parking lot as it moved toward morning.

"By poaching and stealing, Eick's grandfather eventually amassed enough money to marry into a solid middle-class family of shopkeepers in the town, buy a butcher shop and house for his son Arvid. Old Arvid Eick, in turn, was able to send his boy Gotlob to gymnasium and university and a good position in the Potsdam ministry where my great-uncle worked."

Dan listened to a trio soft on the stereo, two women and a protesting man. "The rise of the Eicks. A success story. You want a Coke?"

Mr. Joachim nodded. Dan took the cold cola from the refrigerator, opened one for himself. The dark outside had grown still and black, the moon down and dawn not far away.

"My great-uncle did not socialize with Gotlob Eick, but they sometimes lunched and walked often together in the parks on their way home. The minister himself was a Mannstein, which was why so many families from the village had sons who worked there. It was a tight world, that bureaucracy, but it was changing. Democracy was in the air. People like my great-uncle and the Mannsteins made an effort to bring the Gotlob Eicks into their world, teach them the ways of enlightened civilization."

Mr. Joachim drank the cold cola. "It was Gotlob Eick who was awkward, ill at ease, uncomfortable with the broader habits, tolerant manners, often profligate life-style, and international views of my great-uncle and the Mannsteins. Old Arvid back in the town had sold the shop to a lesser Eick and become a church elder. Gotlob returned often, and his views

remained rooted deep in the village and forest. But he sent his son to the Kinderheim despite doubts about the lax morals and over-liberal influence of the rich and the Jews."

"He didn't know your great-uncle was Jewish?"

Mr. Joachim shook his head with a kind of sad wonder. "It was long before Auschwitz. Gotlob knew perfectly well that my great-uncle was Jewish, but he wasn't *that kind* of Jewish. It did not occur to educated people then that a high-class Jew and a low-class Jew were all Jews. Class counted, status and wealth counted, and young Arvid Eick was sent to the Kinderheim.

"It was a disaster for the boy. He was intellectually slow, had spent a great deal of time with his grandfather, old Arvid. The quicker boys made fun of young Arvid's peasant ways and rural ideas. He was made to feel inferior, became sullen and stubborn. The more they ridiculed his ways, the more rustic and rude he acted. He had no social skills. He considered song, dance, and theater immoral and said so, so was not allowed to sing or dance or recite with the rest. Then things began to 'get lost.' Money began to disappear. Arvid suddenly had more pocket money. He was far too cunning to be caught, and the thefts continued. Then there was a problem in the kitchen with rats."

Mr. Joachim's dark eyes saw those long-ago rats in the kitchen of Hoffman's Kinderheim. "Rats from the forest had invaded the storage larder. Young Arvid said he would catch the rats. The other boys laughed at him—*Ratcatcher! It takes one to catch one.* Arvid Eick only smiled at them. He trapped the rats with small snare nooses that caught their feet. Once caught, he would swing the string and smash them against a wall, leave them squealing with their bloody brains running out until they died. He got them all that way, and there were no more rats."

Mr. Joachim listened to the soaring, final, lost yet noble voices of *Norma*. "When Hitler arrived on the scene in Germany, Gotlob Eick was confused. Minister von Mannstein was not confused. The minister found the Nazis strong, efficient, orderly, and dedicated to the superiority of Germany.

General von Mannstein had no trouble deciding his and Germany's future lay with Hitler. My great-uncle and Graf von Mannstein back in his forest castle were not confused, were totally against Hitler and his barbarian ideas and storm troopers. But Gotlob Eick was confused. The Nazis were his people, but they were not what Gotlob had been taught as truth at the university. He agonized over the illegality of the Nazis, the loss of the proper and orderly ways of doing things, the street brawls and the unrest."

The final tragic voice of the doomed Norma faded away.

"Young Arvid Eick was not confused. He joined the SS as soon as Sepp Dietrich formed the *Leibstandarte,* was noticed at once, and quickly became *Untersturmfuhrer.* He went on to become *Obersturmbannfuhrer* and die in battle, and Gotlob Eick let all the years of self-doubt fall away like a rebirth. He became both Arvids, his old father and his dead son. He saw that his son and Hitler had realized all along that the Eicks were the truth after all, were superior to all false and immoral people like my great-uncle and Count von Mannstein."

The stereo became as silent as the night outside where the new silver-gray Mercury stood in the dark beneath the growing dawn, a jewel in a black-padded box. "After the war, Gotlob also returned to their village near the Mannstein forest. He knew now that my great-uncle was a Jew like any other, that the late Graf von Mannstein had been nothing but a filthy traitor to Germany, and made no secret of his continuing faith in Hitler. He went to prison for a year or two as an unreconstructed Nazi, had no sense of tragedy or loss for either the world or Germany, continued to proclaim that Hitler and the Eicks and the German race would defeat the evil of a degenerate world and rule mankind."

Dan removed the compact disk of *Norma,* and turned the stereo off.

"The other man my uncle knew was the school teacher in the village. By chance he learned of the meetings held toward the end of the war by Graf von Mannstein on his estate to discuss what would have to be done to reconstruct Germany after

the defeat of Hitler. He denounced the Count and ten others who were all arrested. Graf von Mannstein and four others who held positions in the village were executed, the rest sent to the camps. Only two returned. Long after the war had been lost and Germany devastated and the horrors revealed, the schoolteacher never doubted he had done what was right. The ten elderly men had committed the most terrible of crimes. He had done what all proper men had to do."

Outside, the night was utterly still. Only the sparse pre-dawn traffic passed on the freeway.

Mr. Joachim said, "Put the record on again. *Norma*. I feel in need of Druids and immolation tonight."

"I have to get some sleep."

"I will keep it low."

Dan put the compact disk of *Norma* back into the player, turned the stereo on again, and listened as the overture began once more. He listened until the first ancient Druidical chorus, then stood to go back to his own apartment where Moonface the cat still sat in the window.

Mr. Joachim said, "Those who can't feel loss, the defeat in every victory, the pain in all and every joy, cannot really be called human. If you can't feel the loss of even a cat. Then you are the SS, the *Totenkopf*, the smashing of a child's head against a wall."

§

Dan lay in bed in the warm room of late morning sun and listened to the voices out in the parking lot. Voices and passing cars on the streets. Footsteps on the asphalt. Car doors that opened and closed. The voices of children. The solemn, substantial, measured walk of the young husband from apartment E toward his new silver-gray Mercury bought only yesterday and firmly parked in its proper place. The young husband was moving up, walked more powerfully to the new Mercury. A dignified tread. Taking his own proper place on a higher level.

Dan called the zoo to say that he would not be in for work until the afternoon. He went downstairs and ate his breakfast

in front of the window where Moonface sat and looked out. Dan and the old cat both watched the people pass in the parking lot. The young husband from apartment E who paraded back and forth to the new silver-gray Mercury. The young wife who walked behind him, her head turned toward Dan's window with a proud, triumphant smile. Herman Binder who flirted with the manager and her daughter, laughed, and did not look toward Dan's windows this morning. The manager did look toward Dan's windows, toward the old cat in the window.

Dan sat back and listened, a traveler on another planet, among aliens. Binder's bass laughter over the hard, flat voice of the manager and the high raucous chatter of the daughter. Mexican singing and high pitched anger beyond the fence. Mr. Joachim's stereo through the wall. The Song of The Earth. *Der Abschied*. The Farewell. For a small koala and a hundred million years.

When he finished his breakfast, Dan showered and went into his bedroom to dress.

§

In his best suit and white shirt, regimental tie and shined black shoes, Dan drove out to the address of the owner. Mrs. Stockman lived in a large two-story imitation Tudor on two acres at the top of the first slope of the mountains. She was surprised to see Dan. Surprised, but, at first, pleased. She invited him into her living room. Then she was not pleased.

"I'm sorry, Mr. Calder," she said after he had asked, and shook her head angrily that he would dare ask her.

"I wouldn't presume if it wasn't so important, Mrs. Stockman."

"I do allow pets in some of my buildings, but not in that one. There are so many stray cats around there already, Mr. Calder. I have to have them trapped by the city and sent to the humane society."

"I understand, of course. We can't allow cats to overrun us, can we? But Moonface is my daughter's cat. Katherine can't have her cat up in Berkeley, at the university, you know? My

former wife has gone east to take a job and study for her doctorate. There was no practical way she could take the cat. She's old, set in her ways. The cat, I mean, not my wife."

He smiled at the owner. A joke between equals.

"I can't break the rules, Mr. Calder. The others, they wouldn't understand." She shook her head a shade less emphatically. "No, there's no way."

"She never goes out," he explained, his voice sincere. "An indoor cat. Litter trained. She's quiet, does nothing but sit in the window and watch. Like Mr. Joachim, eh?"

He went on smiling. Another joke for the two of them.

"If I let you keep the cat, Mr. Calder, I'd have to let other people."

"I can't do anything to harm my daughter's cat, you see? I mean, she's had that cat all its life. She'd never forgive me."

"Mr. Binder gets upset about animals too, he gets over it. I'm sorry, Mr. Calder."

"Binder is a decent man," he said. "My daughter, you see, simply couldn't understand if I abandoned her cat. She believes in being responsible for life, even a cat's, and she wouldn't have gone away if my wife and I hadn't promised to take care of old Moonie. Now my wife's going away herself, and I know she'd take Moonie with her if she could, but she can't at this time."

"I'm very sorry."

He nodded sadly. "Yes, I understand. I understand what you have to do. I'm sad too. I like it in that apartment. It's a really nice place. Too bad. I don't look forward to trying to find another apartment that convenient and pleasant."

Mrs. Stockman put her hand to her throat, sat down on her leather and chrome couch.

"You'll leave?"

"I'll have to, won't I? I mean, I can't abandon the poor old animal or my daughter. Moonie doesn't have many years left. It's not her or my daughter's fault my wife had to go east."

"You'd move out? For a cat?"

"I don't see any other way. I certainly don't want to. It's a

fine building, clean and well run. Everyone on the zoo staff says how lucky I am."

"You're comfortable there?"

"Very, I really enjoy it."

Mrs. Stockman smoothed her skirt with her small hands.

"How old is the cat?"

"She must be, let me see, at least thirteen now. Yes, my daughter got her when she was six."

"That's old for a cat."

"And she's a real loner. Always did stay to herself. I could keep her out of the windows. She'll never go out. My wife hopes to be able to take her back soon, and, of course, when my daughter graduates and has a place of her own she'll want her old Moonface."

"How long have you had her there now?"

"It must be almost two months, perhaps more. I've been so busy with problems at the zoo, and she's so quiet, one forgets she's there."

"No one else has complained. Carrie would have told me."

"If she ever causes any trouble, all you have to do is tell me and that's the end of it."

"There shouldn't be any if she stays in the apartment, keeps out of the windows."

"Then I can tell my ex-wife I can keep the cat at least a few months until she can send for her?"

"Well, I expect something can be worked out."

"I appreciate that, Mrs. Stockman. I think a couple of men on our staff at the zoo need apartments. When you have one available, let me know at once, and I'll speak to them, eh?"

"I might have some openings soon. Are they professionals too?"

"Oh, yes. Veterinarians and zoo administrators."

"Have them call me."

"I will." He stood, smiled his gratitude. "You'll tell Mrs. Anson? About Moonface? I'd appreciate it if she knew as soon as possible, doesn't think I'm doing something she has to stop."

"I'll call her today."

"Thank you, Mrs. Stockman. I really do appreciate your understanding."

He drove back to his apartment, changed his suit, white shirt, tie and polished shoes, and immediately went to the zoo. The autopsy report on the koala showed that the fifteen-month old marsupial had died of heart failure brought on by stress. The change, the new life under a thousand eyes, had been too much for the little animal with a two-digit blood pressure born to a slow, changeless life. But Dan knew she had died of sorrow, of loss, of the weight of a hundred million years gone and to come.

That evening he sat at his open window with Moonface on his lap. The manager came to stand outside the fence of his private concrete patio.

"She called me."

Dan stroked the silent cat on his lap.

"You be sure you keep that cat inside."

Through the walls Mr. Joachim was playing the Mahler Ninth that was really the Tenth.

"You got no right to break the rules."

Over the large trash and garbage containers, and on the fence at the entrance to the lot, the manager had bolted metal NO TRESPASSING signs that could not be easily removed.

"No one got no right to break no rules."

Dan saw the implacable certainty in the manager's small eyes. He felt the purr of the old cat pulsing through his hand as he gently stroked it. He listened to Mr. Joachim's and Gustav Mahler's farewell music through the walls.